ART
JOURNAL
YOUR
ARCHETYPES

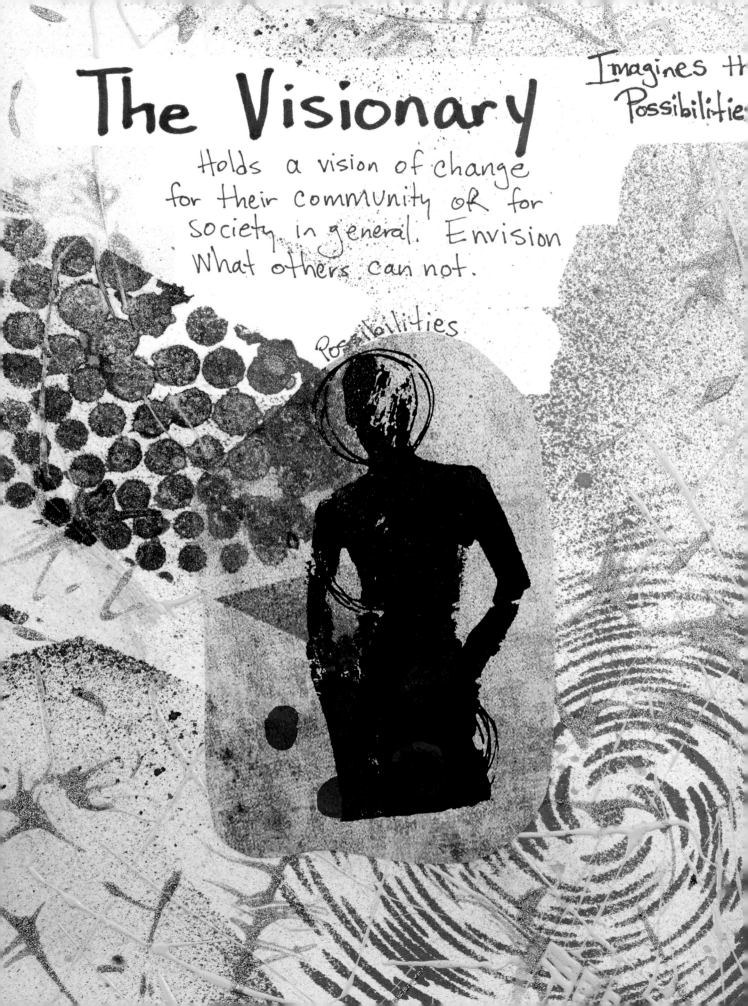

ART JOURNAL

YOUR

ARCHETYPES

MIXED-MEDIA TECHNIQUES FOR FINDING YOURSELF

GABRIELLE JAVIER-CERULLI

NORTH LIGHT BOOKS
CINCINNATI, OHIO
clothpaperscissors.com

CONTENTS

WHAT YOU'LL NEED

SURFACE
- art paper or art journal

PAINTS
- craft paints
- high-flow acrylic paints
- PanPastels
- Tim Holtz Distress Paints
- watercolors

BRUSHES
- flats and rounds in various sizes

MARKERS
- Copic
- Letraset
- Prismacolor
- Sharpie

STENCILS
- Pam Caraker L171; Doodle It Geometric Landscape; Face Map Front Version 2; Jessica Sporn's Paisley Floral Repeat; Shattered; Tall Birds; Unconnected Circles by StencilGirl
- Cursive Alphabet; Mix Tape; Rain; Circle Explosion by The Crafters Workshop
- Diagonal and Dots; Jane Girls Series—Three-Quarter by Artistcellar
- Letter Jumble by Dylusions
- Splatter by Tim Holtz

OTHER
- acrylic glaze
- Angelina film
- brayer
- candle
- cardstock
- Clear Tar Gel or String Gel
- collage papers
- ColorBox stylus and ink
- color wheel
- Copic Airbrush System
- deli paper
- Derwent Inktense Blocks
- fine-grit sandpaper
- floral wire
- gaffer tape
- Gelli Arts Gel Printing Plate
- gel medium
- gesso (clear, black and white)
- glue
- heat gun or hair dryer
- highlighters
- ink pads
- ink spray
- Jessica Sporn Peacock Motif stamp by RubberMoon
- kneaded eraser
- Kreate-a-lope envelope template
- latex gloves
- magazine cutouts
- matches or lighter
- microscope glass slides
- mini spatula
- Mod Podge
- nail polish
- old credit card
- origami paper
- palette knife
- paper towels
- pencils
- postcards
- Ranger Mini Ink Blending Tool
- rice paper
- rubber bands
- Schmincke colored masking fluid
- scissors
- scrapbook paper
- sketchbook
- Sofft tools
- sponge corner roller
- spray bottle or mister
- spray fixative
- used postage stamps
- washi tape
- watercolor paper
- wax paper
- webbing spray
- white transfer paper
- wire cutter

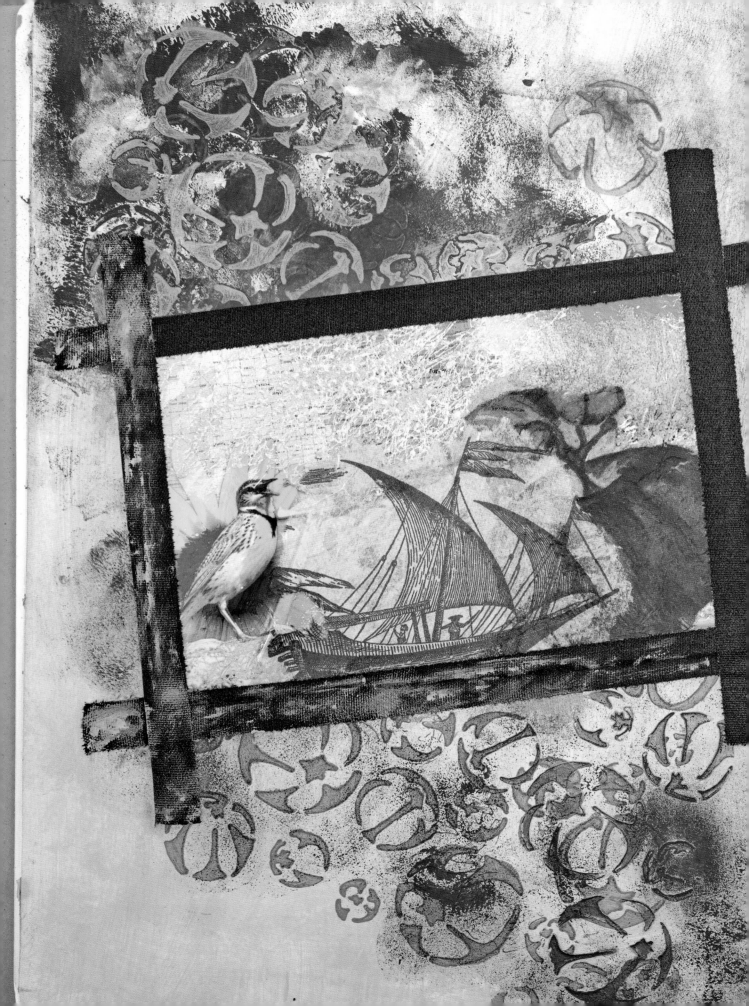

INTRODUCTION

When I was in my early thirties I had a job as the director of communications for an arts advocacy organization. While I loved the mission of the organization, I realized that I was too removed from the action. I (my true self) wanted to be an artist, a creative, not an office administrator. It was at that same time I learned about art therapy and drumming groups, and I went on to get my M.A. in expressive arts therapy.

However, within a few years of obtaining my degree, I knew my soul was trying to tell me something. This had become my inner dialogue: *Art-making with others all week long? Yes! Helping people? Yes! Being a one-on-one therapist or family therapist? No!* Wait—why no? I had just spent so much time, money and energy on obtaining a master's degree that I loved. And now I didn't want to do it as a career? That's right. Uh-oh. There was a problem.

So I listened to my gut and decided not to go the safe, logical route of becoming a licensed therapist. But now what was I supposed to do with my degree—and the rest of my life? I searched for answers through journal writing, visualizations and vision boards, but there weren't any revelations. No path was appearing before me. I needed to get back to the basics so that I could answer the question, "Who am I?"

The answer came via archetypal work. I unveiled who I truly was and who I truly was not. I learned that although it surrounds me, The Healer is not one of my core archetypes. So that explained why I didn't want to become a therapist. I also learned that two of my core archetypes are The Liberator and The Artist. They are the forces motivating me to write this book. They want to show you a low-stress way to exercise your creativity and help you discover something new about yourself in the process.

Will this book change your life? I audaciously and cautiously answer, "Heck, yes!" You are holding 128 pages of creative liberation in your hands! You will be led to a new level. Discovering your core archetypes will bring clarity to your career and relationships. You will come to understand why you have made certain decisions in the past that have led you to your current place in life. With this clarity comes a level of self-acceptance, which is the foundation of self-love. And we all could love ourselves a little more, right?

First you'll learn about the different archetypes, and then I'll help you unveil your own. Finally, I'll show you how to use your core guiding archetypes as inspiration for art journal pages. By art journaling your archetypes, you will come to understand them (and yourself) better. Step by step, I'll walk you through some awesome art techniques you can use to enhance your own journal pages. Eleven other fabulous contributing artists will also share their journal pages and creative processes to help awaken your creative juices.

Now get ready to learn something new about yourself—and make some art!

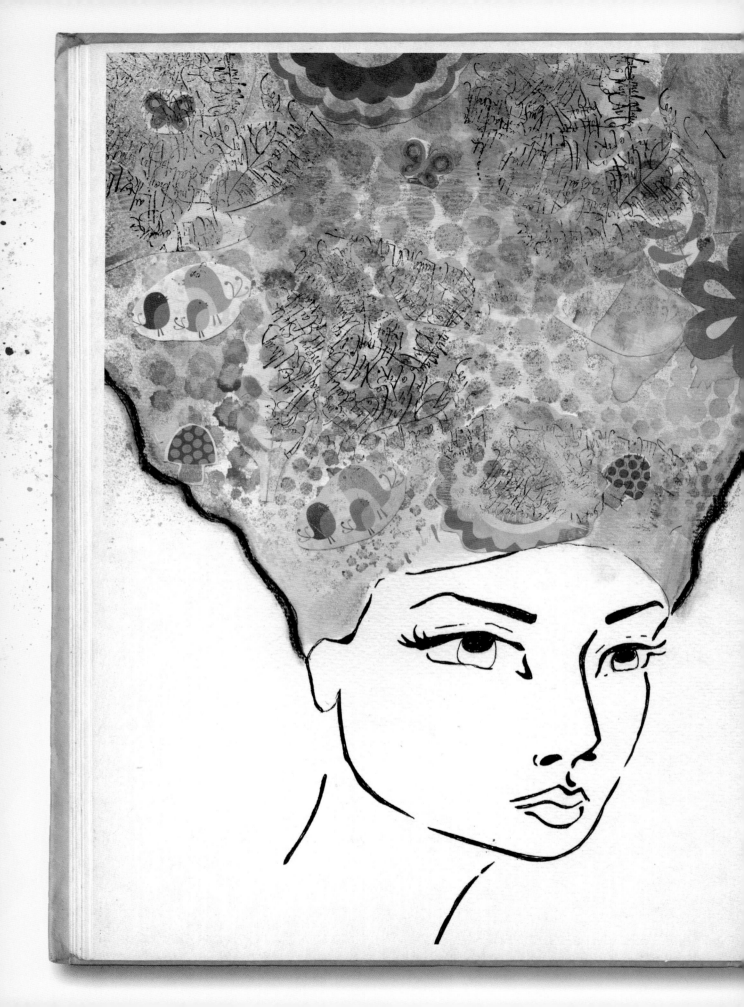

part 1
GETTING STARTED

Art journaling is very popular right now. People love the freedom of mixing art materials to create unique, non-traditional, personal artwork on journal-sized paper. In an art journal, you can take risks and try new things. And you don't need to commit a huge amount of time—in just 15–30 minutes, you can squeeze in a fun art project to help decrease your stress and anxiety levels.

Art journaling is quicker and easier than my usual media of choice—large-scale acrylic paintings. I began art journaling by creating mixed-media pages based on my archetypes. It was a natural way for me to explore the meanings of these energies. Now I wish to share this process with others who seek art journaling instruction with a personal development undertone.

Introducing the two worlds of art journaling and archetypes to each other is really exciting. Experienced art journalers will learn how to use their guiding archetypes as inspiration for future art journal pages. Those who picked up this book mainly to discover their guiding archetypes will be introduced to the colorful world of art journaling. It's going to be a fun ride for everyone!

WHAT IS ART JOURNALING?

An art journal is exactly what it sounds like: a journal where you make art. It is simply a place to create. There aren't any rules. It can be a place to be reflective and even therapeutic, or not. It can be soul-nurturing, or not. There can be words on the pages, or not. You can use traditional mediums, or experiment and play with ink sprays, stencils, sewn bits, lettering, gesso, altered photographs and so much more. It can be any size. It can be a bound book or loose pages held together with a binder clip. It can be *process focused* or *results focused*.

Results focused (or product focused) is when the concern is about the final look of the completed page. Does it flow?

THE REBEL
Nathalie Kalbach
Mixed-media art journal page with markers, acrylic paint, gesso, stencils, stamping, magazine cutouts and a variety of collage paper.

Does it look nice? Is it aesthetically pleasing? Typically, there will be a set of steps to follow to produce the page. In contrast, process focused does not have a specific intent, and there isn't a concern with what the end product is. With these types of pages, usually there are not step-by-step instructions or samples to follow, because they are not intended to be duplicated exactly. The pages are entirely your own. (This idea is most often stressed in art therapy sessions.)

Some folks start off with results-focused art journals because this kind of self-expression is so brand new that they need some guides to help them get acclimated. After a few completed journals, they may then drift to process-focused journaling because they're comfortable with the art materials and are ready to branch out, listen to their inner wisdom and create whatever comes forth. My art journals are a mix of process- and results-focused pages. I am more willing to show people my results-focused pages, of course.

WHY DO PEOPLE MAKE ART JOURNALS?

One thing that all art journals have in common is that they can be created at home without fancy and expensive art supplies. You do not need to take classes, or have an art studio or have

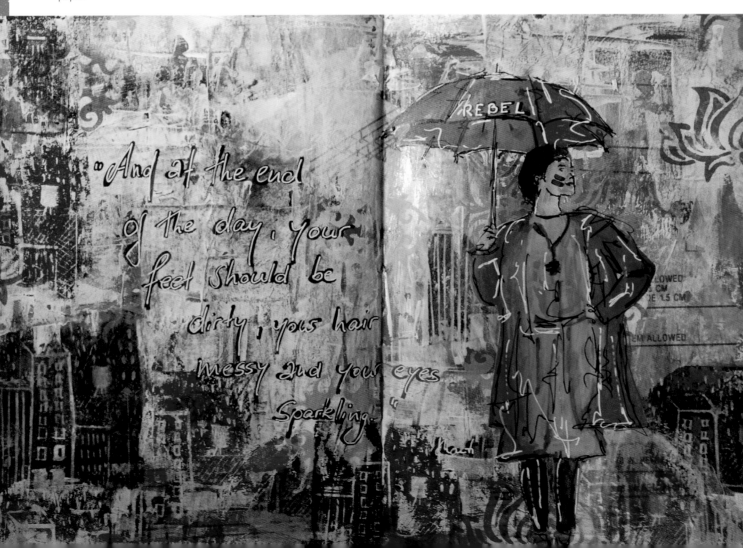

been born with natural drawing abilities in order to flourish at art journaling. I think that's its main appeal—everyone can do it!

Of course, there are many classes and workshops on art journaling—both live and online. There are supportive Internet forums and Facebook and Flickr groups that you can join to learn techniques, get daily art-journaling prompts and share your journal pages. There are also many books dedicated to this fresh, personal way of expressing yourself. (Check out books by Dina Wakley.) At the time of this writing, there are eighty-seven Meetup groups in seventy-eight cities in nine countries that do art journaling together. So, if you're looking for a community (either online or offline), it's easy to find one with art journaling.

As with written journals, by reviewing the pages of your art journal, you may see patterns appear over time. Those patterns can either be your artistic style emerging and shining through, or they may be patterns of behaviors, thoughts and messages or advice for you. Either way, the art journal is an unparalleled insight into *you*.

MUST I BE AN ARTIST TO MAKE AN ART JOURNAL?

In short—no you do not have to be an artist to make an art journal. So many art facilitators, art teachers and artists will sing in unison, "Everyone is an artist!" "Everyone is creative!" "Everyone craves a creative outlet!" I don't believe this to be true because I've met far too many people who have absolutely no interest in self-expression. As an archetype consultant, I can attest to the fact that the majority of my clients do not have The Artist as an archetype.

But even if you would not label yourself as "an artist" or "artistic," art journaling can still be a fun, rewarding endeavor for you. The majority of people in a yoga class are probably not The Athlete or The Mystic archetypes, but they still enjoy it. So, although you may not have artistic proclivities, art journaling may be exactly what you need in your life right now.

THE NATURE GIRL
Orly Avineri
Mixed-media art journal page with acrylic paint, pen, collage paper, carbon paper, sandpaper and peelings.

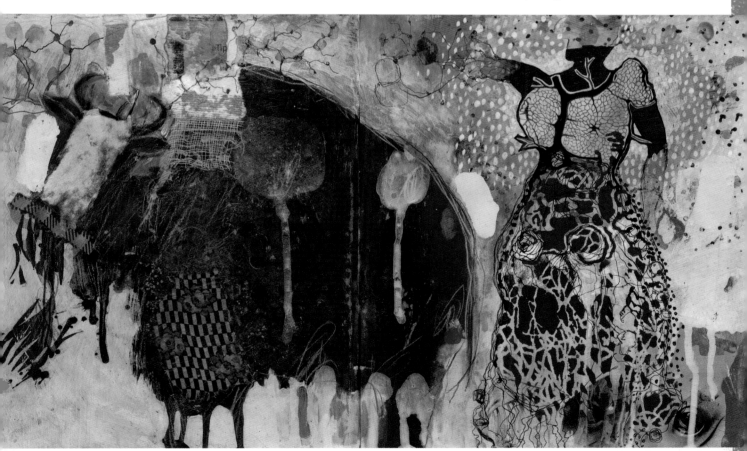

WHAT ARE ARCHETYPES?

When I tell people I'm an archetype consultant, it's funny how often they mishear me and think I've said I'm an architecture consultant. I'm not sure why the word "archetype" isn't ingrained as common knowledge. It should be because archetypes are literally everywhere. Archetypes are used in literature, script writing, marketing, branding, self-help, psychology, sociology, mythology and even the tarot. But still, the concept often seems obscure.

Swiss psychologist Carl Jung, who popularized the notion of the archetype as an expression of human experience, defined an archetype as "an inherited pattern of thought or symbolic imagery derived from the past collective experience and present in the individual unconscious." Another way of saying this is that archetypes are simultaneously society's energetic blueprint as well as your own energetic blueprint. They are seen in people at the macro and micro levels.

Caroline Myss, who is one of today's leading teachers of archetypes, says, "Knowing your archetypal patterns is the beginning of understanding why you are the way you are."

Be careful not to confuse archetypes with stereotypes. They are not the same thing! An archetype is a representation of humankind, while a stereotype is typically a negative, oversimplified idea of a person. An archetype is a repeated pattern of behaviors based on the decisions you've made or wish to make in your life.

These patterns can show up in your career choices, college majors, relationships, how you spend your money, your spirituality and all other areas of your life. Why you choose to do something or not to do something can be threaded back to your guiding archetypes. For example, because of my Artist and Liberator archetypes, I have chosen to write this book instead of trying out for a role in a community theater production.

THE MYSTIC
Jessica Sporn
Mixed-media art journal page with paint, gesso, white Posca marker, Gelli Plate stamping, Jessica's Tree of Life and Peacock Motif stamps and her Krishna Deity stencil.

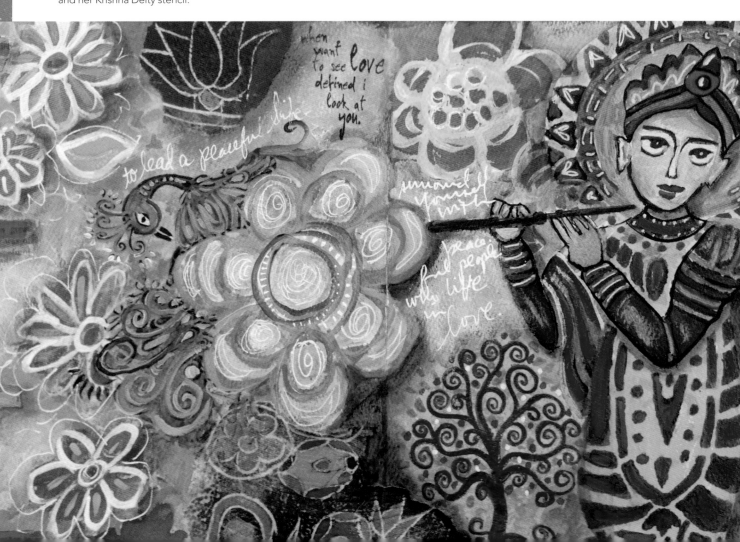

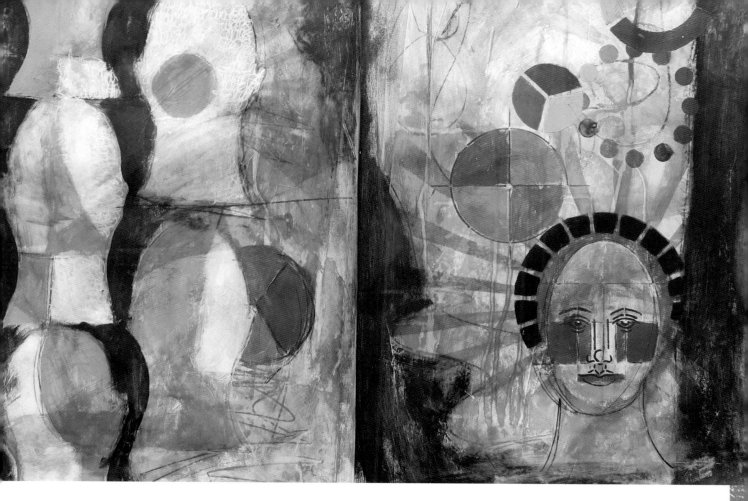

COMPARTMENTS
Mary Beth Shaw
Mixed-media art journal page
with gesso, white pen, Posca
markers, Derwent Inktense pencil,
Matisse Pam Carriker's Fluid Matt
Sheer Acrylics, Jo Sonja Artists'
Colours and Circle Rays stencils by
StencilGirl.

I first became aware of archetypes while traveling in my early twenties. No matter where I went—India, Korea, Bali, Saipan, London, Boise or Baltimore—there seemed to be the same kinds of people everywhere. There was always The Politician, The Artist, The Comedian, The Athlete, The Mother, etc. The world didn't seem so big because of this. What I was actually picking up on was archetypal energies.

I deepened my understanding of archetypes while obtaining my master's degree. There are hundreds of archetypes. Some of them, like The Warrior, have been around since the beginning of time. Others are new, such as The Computer Geek. Some archetypes can have multiple forms. For example, The Mother can splinter into The Working Mother, The Stepmother, The Doting Mother, etc. In this book, you will get to know the thirty-three main archetypes that show up most commonly with my clients.

It is important to keep in mind that archetypal energy is fluid and can change gradually over time due to maturation or life transitions. So there will be times when one guiding archetype steps down and is no longer as active, while a different archetype emerges and becomes a core. This would not be something that happens overnight, but rather a slow change. You'll notice that your focus is on something different, or you're spending your time, money and energy on something more than you once did.

Discovering your core archetypes will unveil a new layer of yourself—a layer beyond interests and skill set. You will learn who you are and (maybe more importantly) who you are not. This new knowledge is essential for self-acceptance, happiness in your career and clarity about your relationships. If you are in business, this information will also help you authentically market yourself. You will be able to answer that proverbial question we've all asked ourselves, "Who am I?" You'll be able to answer it with pride, acceptance and love. Your past and present will be recalibrated and brought into focus.

DISCOVER YOUR ARCHETYPES

As humans we are constantly seeking clarity. People often voice their desire to understand who they truly are and where their true strengths lie. Essentially people are seeking to know what makes them special. One way of finding this clarity is by unveiling and understanding your eight core guiding archetypes. This information will help you make confident decisions about yourself, your careers and your relationships. (Keep in mind that eight is the average number of guiding archetypes for most people, but you could have as few as six or as many as ten core guiding archetypes.)

To determine your guiding archetypes, answer each question by circling the number that best represents you today. Make sure you select the truth of who you are today, not who you used to be or who you wish to be.

1. Doesn't sound like me at all.
2. It sounds a little bit like me, or maybe like me years ago.
3. It somewhat sounds like me, but it only applies about half the time.
4. I spend a lot of my time, money and/or energy here, but it's still not 100% accurate.
5. Oh yes! This is definitely me!

TAKE THE TEST

1 Are you a pleasure seeker? Do you indulge frequently in any of the following: parties, drinks, gourmet foods or other luxuries?

1	2	3	4	5
not at all				definitely me

2 Do you enjoy telling stories either verbally, written and/or in your artwork? Are you communicative?

1	2	3	4	5
not at all				definitely me

3 Do you have a pattern of moving from one job, relationship or spiritual practice to another? Do you feel like you're constantly looking for something else? Never quite satisfied?

1	2	3	4	5
not at all				definitely me

4 Do you have a knack for problem solving? Do you use your creativity to approach challenges and come up with practical solutions? Do you like systems?

1	2	3	4	5
not at all				definitely me

5 Do you often find yourself in leadership or manager roles? Do you make the decisions at work and/or at home, especially the tough decisions? Are you the one in charge?

1	2	3	4	5
not at all				definitely me

6 Do you like to meet new people? Do you instinctively bring people together? Do you enjoy collaborations?

1	2	3	4	5
not at all				definitely me

7 Do you often need time of solitude? Do you enjoy, usually prefer, being by yourself? Are you not lonely when you are alone?

1	2	3	4	5
not at all				definitely me

8 Are you funny? Do you use humor often? Have you been told you are witty, funny, silly or humorous? Do you often lighten heavy situations with jokes?

1	2	3	4	5
not at all				definitely me

9 Are you endlessly exercising your creativity? Is visual self-expression a priority to you either by designing, crafting, fashion, art-making or home décor?

1	2	3	4	5
not at all				definitely me

10 Do you enjoy business development or do you often have money-making ideas? Do you like the idea of being your own boss?

1	2	3	4	5
not at all				definitely me

11 Do you feel like a born instructor? Do you enjoy educating others and passing along your knowledge? Do you like training others?

1	2	3	4	5
not at all				definitely me

12 Are you deeply connected to any of the following: water, beach, woods, forests, nature or animals? If you didn't engage with one of these elements often (daily or weekly) would you feel grumpy?

1	2	3	4	5
not at all				definitely me

13 Are you drawn to heal the physical, mental or emotional pain in others? Do you see yourself as a curative entity?

1	2	3	4	5
not at all				definitely me

14 Is your spirituality of high priority? Are you deeply connected to God/Source/Universe/Positive Energy? Does this connection sustain you? Do you often check in with this connection?

1	2	3	4	5
not at all				definitely me

15 When conflict arises, do you stay and fight, either verbally or physically? Are you assertive, maybe even aggressive at times? Do you speak up for yourself and sometimes for others? Are you always at the ready for conflict?

1	2	3	4	5
not at all				definitely me

16 Do you have a pattern of exploring and seeking adventures? Are you a do-it-yourself kind of person? When life is steady, do you need to shake things up?

1	2	3	4	5
not at all				definitely me

17 Throughout your life, have you gone against the status quo and lived your life differently from the mainstream? Are you a nonconformist?

1	2	3	4	5
not at all				definitely me

18 Are you currently enjoying nurturing and/or raising children or pets? If you're not currently, do you have a very deep desire to do so one day?

1	2	3	4	5
not at all				definitely me

19 Are you comfortable in the literal or figurative spotlight? Do you enjoy the give-and-take between you and an audience, no matter if it's a few people or a few hundred people?

1	2	3	4	5
not at all				definitely me

20 Would you rather play than work? Are you a little immature, yet people usually like your silly behavior? Do you sometimes feel a bit wide-eyed and naïve? Do you prefer for others to be the responsible ones?

1	2	3	4	5
not at all				definitely me

21 Do you spend time, money (such as donations) and/or energy on a cause(s)? Do you educate others about certain issues? Are you a champion for a cause? Would you call yourself an activist or an avid supporter?

1	2	3	4	5
not at all				definitely me

22 Do you celebrate being a woman? Are you intuitive? Do you believe in the "Power of the She"? Do you tend to like to work with other women?

1	2	3	4	5
not at all				definitely me

23 Are you called to empower others and free them from self-limiting mindsets? Do you enjoy helping people get unstuck and live a fuller life?

1	2	3	4	5
not at all				definitely me

24 Do you have a big heart? Are you passionate and compassionate? Do you accept people just as they are? Are you extremely empathetic?

1	2	3	4	5
not at all				definitely me

25 Do you enjoy being a support to someone and being their guide? Do you often find yourself coaching, advising or mentoring individuals?

1	2	3	4	5
not at all				definitely me

26 Do you see yourself as a student of life and a lifelong learner? Do you believe knowledge is power? Do you often take classes or workshops? Do you sometimes feel as if you need to keep learning because you're not ready to be a teacher or an expert?

1	2	3	4	5
not at all				definitely me

27 Do you have ideas for making a difference and bettering your community, your field of work and/or society? Do you see the possibilities for changes and have the drive to work towards them?

1	2	3	4	5
not at all				definitely me

28 Are you deeply connected to words? Do you write a blog, diary or journal? Is writing your job? Do you feel comfortable and confident expressing yourself with written words?

1	2	3	4	5
not at all				definitely me

29 Do you enjoy researching and gathering information, then synthesizing and assembling it? Or gathering stories and/or photos and producing a presentation, a book or an album?

1	2	3	4	5
not at all				definitely me

30 Are you really good at piecing clues together and solving puzzles? Do you have hunches about people or situations? Are you sometimes nosy?

1	2	3	4	5
not at all				definitely me

31 Do you act as a first aid kit for others? Are you usually the first person people call in a time of crisis? Have you taken in stray animals or adopted from rescue centers?

1	2	3	4	5
not at all				definitely me

32 Have you had a comfortable life provided by either parents, spouses or partners? Do you take care of how you look? Are people attracted to you?

1	2	3	4	5
not at all				definitely me

33 Are you critical or judgmental of other people when it comes to the decisions they make? (It can be anything from what they wear to how they raise their kids.) Are you opinionated? Do you expect people to follow sensible rules, laws or the flow of things?

1	2	3	4	5
not at all				definitely me

CALCULATE YOUR RESULTS

Look at the questions where you circled 5. If you have more than eight questions where you circled 5, review each one to see if some are not as strong as others. Ask yourself, "Is this really my core? Do I really have a pattern here?" Also make sure you are answering as the person you are now. Are you certain you're not wishing to be that archetype vs. really being that archetype?

What if you only have a few 5s? Then review your 4s to see which are truly strongest for you. Not enough 4s? Look at your 3s.

Congratulations on unveiling your core guiding archetypes! Here are the corresponding archetypes to each question:

1 Hedonist	**18** Mother/Father
2 Storyteller	**19** Performer
3 Seeker	**20** Eternal Child
4 Engineer	**21** Advocate
5 King/Queen	**22** Goddess
6 Networker	**23** Liberator
7 Hermit	**24** Lover
8 Comedian	**25** Mentor
9 Artist	**26** Student
10 Entrepreneur	**27** Visionary
11 Teacher	**28** Writer
12 Nature Guy/Gal	**29** Scribe
13 Healer	**30** Detective
14 Mystic	**31** Rescuer
15 Warrior	**32** Princess/Prince
16 Pioneer	**33** Judge
17 Rebel	

When Mother Nature calls... LISTEN.

Hawk has visited me two days in a row now, sitting in the tree right outside my window. Hawk is the messenger of the spirit world. She provides wisdom about seeing situations from a higher perspective, observing and focusing + developing spiritual awareness.

MOTHER NATURE
Lisa Cousineau
Mixed-media art journal page with Chakra pocket stencils from Artistcellar, texture paste, paint, markers and Gelli print.
Lisa Cousineau is the owner of Artistcellar (artistcellar.com).

NEED MORE HELP?

Do you need more help deciphering your archetypes? Or would you like some clarification about a specific archetype? You have a few options:

- Do an Internet search about the archetypes in question.

- Check out books by Caroline Myss or Carl Jung.

- Work with me. We could have a 15- or 30-minute chat over the phone. Or if you prefer, I could do a full 90-minute session in person, over the phone, or via Skype or Google Hangout. Please go to my website, gabriellejaviercerulli.com and complete the contact form. You can also email me at KnowYourArchetypes@gmail.com.

MEET THE ARCHETYPES

The following is a list of the thirty-three most common archetypes I have found with my clients, along with their characteristic traits. Remember, there are hundreds of archetypes out there. These are simply the most common ones I've come across in the course of my work.

THE ADVOCATE

You are passionate about a cause or an issue. You support, defend, promote and campaign. You spend your time or donate money to charities or non-profits. There's a fire of passion for these causes, and you are moved to educate others about them as well—through sharing posts on social media, writing letters to politicians or working for such organizations.

THE ARTIST

You are always "arting," continually creating. This most often takes the form of visual art such as paintings, drawings, sculpture, sewing or graphic design. It can manifest through gardening, home décor or fashion. Self-expression is a priority for you.

*Note: I have found that the word "Artist" sometimes makes people uncomfortable because it feels too exclusive. If you prefer, use the term, "The Creative" instead—especially if you work in multiple modalities of self-expression, such as poetry, design, music, cake decorating, etc. This archetype list doesn't include other archetypes with artistic souls such as The Musician, The Poet or The Dancer, but feel free to include them under the Artist umbrella.

THE COMEDIAN

You've been told you're funny, witty, snarky or a jokester. You use humor when speaking, writing or making art. You sometimes use your sense of humor to cover up your true feelings.

THE DETECTIVE

You connect the dots, put the pieces together and solve riddles, mysteries or puzzling situations. You can "read a room" and pick up the vibe of the people there. You trust hunches and gut feelings. You have a keen intuition. You may even be a busybody. (See also Mystic and Goddess.)

THE ENGINEER

You are a problem-solver. Your creativity is used for fixing, modifying and bettering situations, products or services. You may be a tinkerer and you probably like to have systems in place so that things can flow smoothly.

THE ENTREPRENEUR

You are a business owner or have plans to be. You excel in business development and growth strategies. If you work full-time, you may be trying to start a business on the side.

THE ETERNAL CHILD

You are all about fun and play. You'd rather have a good time than work. You are sweet and possibly a little naïve. You may get along well with children. You wish to keep the innocence of childhood and avoid the stress of being an adult.

THE GODDESS

You honor and celebrate being a woman. There's a feminine strength to you. You may adorn yourself or keep your surroundings beautiful. You believe in womanhood and may even choose to work mostly with other women. There may be a sensual quality to you. You are highly intuitive. (See also Detective and Mystic.)

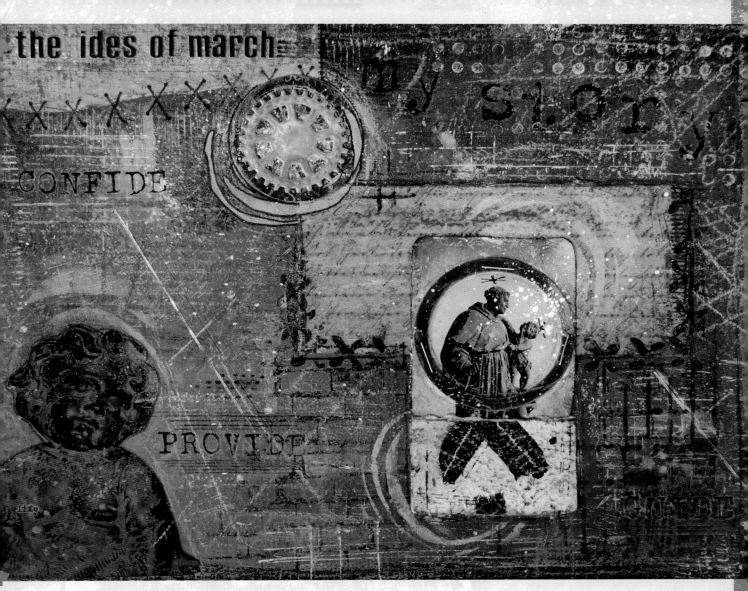

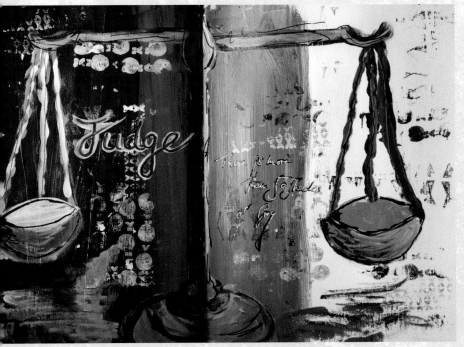

IDES OF MARCH
Seth Apter
Mixed-media art journal page with black and white gesso, oil and wax pastel crayons, black and white gel pens, water- and paint-based markers, acrylic paint, solvent ink pads, ephemera, hand-painted paper, altered photographs, rubber and acrylic stamping, stencils, stickers, rub-ons, copper sheeting, contact paper, cardstock, leafing pen, patina solution and resin. This art journal page represents Seth's Mentor, Father, Healer and Scribe archetypes.

THE JUDGE
Nathalie Kalbach
Mixed-media art journal page with black and white acrylic paints.

19

THE HEALER

You are curative and feel a calling to heal the pain in others. This pain can be physical, emotional, mental or spiritual. You have an inherent ability to serve and repair.

THE HEDONIST

Life is to be experienced voraciously, and that can include indulging in wine, cocktails, parties, gourmet food, luxury travel, nice clothes or even coffee, chocolate or sweets. You treat yourself to the good things in life. What those good things are will be different for everyone, but Hedonists will spend a good deal of time and money on their pleasures.

THE HERMIT

Breaks from the outside world and from people are necessary for you. You value your alone time; however, this does not mean that you're anti-social. You are introspective as well.

THE JUDGE

You are opinionated and critical of other people, and you will share your true thoughts with others. Your opinions can range from judging the way people choose to live their lives, to how they raise their families, to their fashion choices. You may be a professional critic. You believe in a balance of power and fairness.

THE KING/QUEEN

You are a leader, manager or boss of some kind. (This can mean a CEO, head of the PTSA or Queen Bee of your home.) You either seek out these roles, or are placed in them because you've demonstrated that you take responsibility seriously, get things done and are accountable. You make decisions with confidence.

THE LIBERATOR

You empower others. You aid them in living a more mindful and fuller life, so they can be untethered from negative mindsets. You are most likely a personal development enthusiast.

THE LOVER

You have a big heart and you give and give. Your motto would be, "Why can't we all just get along?" You are empathetic. You don't judge others; you accept people as they are. People don't need to prove themselves to you. You are very compassionate.

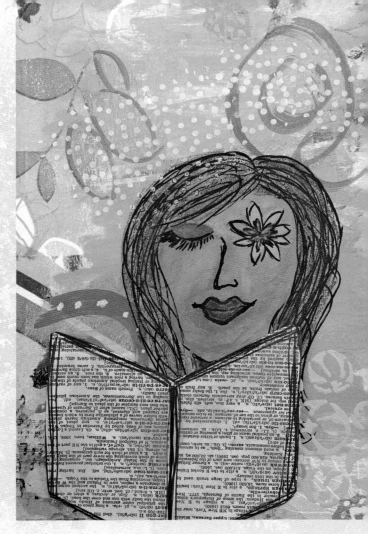

THE STUDENT
Gabrielle Javier Cerulli
Mixed-media art journal page with collage.
She is always learning something new!

THE MENTOR

You are a coach, guide, supporter and advisor. You help people get from point A to point B. You keep people on track. You are approachable—clients/mentees/students/employees/coworkers can ask you questions—and you're happy to help them out. People value your time and concern for them.

THE MOTHER/FATHER

You are a nurturing caregiver to children, pets, family members, friends or coworkers. You enjoy enriching other's development and celebrating their successes and milestones. You are warm and encouraging. Your guidance and encouragement are gifts. You can have this archetype even if you are not an actual parent.

THE MYSTIC

You have a deep connection with something not of this planet—whether it be God, Goddess, Source, Universal Energy, etc. This connection is instrumental in your daily living and touches all areas of your life: personal, professional and spiritual. You check in with this connection often since it guides, comforts and sustains you.

THE NATURE GUY/GAL

You are deeply connected to something in nature, be it the ocean, desert, woods, mountains or animals. You make decisions that allow you to be closer to these elements so you can access them more frequently. You feel comfortable, whole and happy in your natural element and get grumpy if you don't experience it for some time.

THE NETWORKER

You are a social connector. You are resourceful and proficient at sharing information, as well as linking people to each other. Collaborative opportunities excite you.

THE PERFORMER

You enjoy having an audience and being in the spotlight. You can "perform" as a musician, dancer, model and actor but also as a speaker, teacher, trainer or lawyer. You possess a strong desire to captivate attention and to have an audience.

THE PIONEER

You are independent, an adventurer and an explorer. You have a pattern of doing things that haven't been done before. You stretch yourself—you are comfortable being uncomfortable. When life reaches a plateau, you'll shake things up (either by going back to school, switching jobs, changing relationships, etc.) in order to grow. Innovation and DIY may be some of your biggest strengths. Security is not a high priority for you.

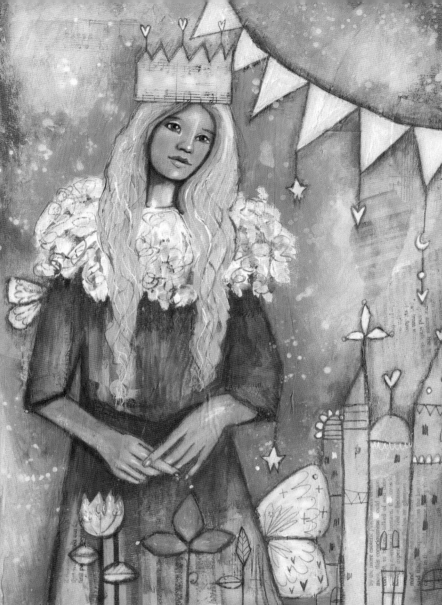

THE QUEEN
Tamara Laporte
Mixed-media art journal page with scrapbook paper, cocktail napkins, magazine cutouts, clear gesso, Caran d'Ache watercolor crayons, white acrylic paint and graphite pencil.

THE PRINCESS/PRINCE

You are attractive and people are drawn to you. You take care of how you present yourself to the world. You are youthful. You haven't wanted for much; either your parents or your boyfriend/girlfriend or spouse have provided a comfortable life for you.

THE REBEL

You think independently and do not follow crowds or trends. Thus, you typically live life differently from the mainstream. Conformity does not interest you, and may even frighten or suffocate you. You're unconventional.

THE RESCUER

You are reactive and responsive, and you improve other people's situations. You are the first person someone calls in a time of need. You may have loaned (or given) people money, your car or a spare bed. Or you may have rescued or adopted animals. You may donate money to rescue organizations. You are prepared to give emotional or physical assistance, and you may even carry a first aid kit.

THE SCRIBE

You are a researcher. You gather information, synthesize it, then produce or assemble something with it. You collect data, keep records and/or record events. This archetype could be journalists, secretaries and accountants. But it can also be the family scrapbooker, gathering stories, photos and ephemera to create a record of family life that year.

THE SEEKER

Your gift is your continued thirst for truth—in finding the right job for yourself, the right spiritual practice or the right partner. This causes you to switch gears regularly. You may feel like a wanderer at times.

THE STUDENT

You are a learner. You are consistently taking classes, workshops, reading books or getting another degree. Knowledge is power. Sometimes you may not feel ready to be the teacher or the expert. You always feel there is more to learn.

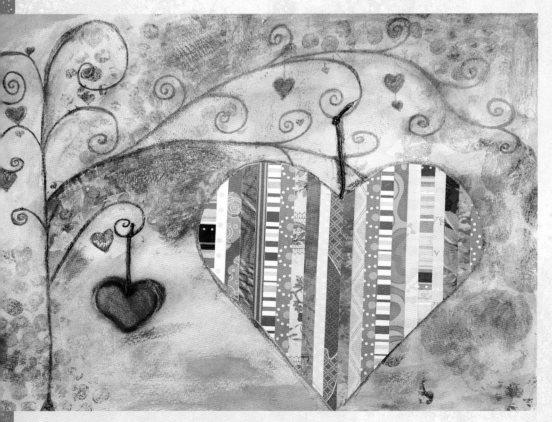

A MOTHER'S LOVE
Gabrielle Javier-Cerulli
Mixed-media art journal page with collage. This page symbolizes how caring for a child is one of the greatest gifts to The Mother archetype. She will help her child grow and flourish while providing security and being protective.

THE STORYTELLER

You enjoy telling stories and sharing your experiences or bits of wisdom with family, friends and coworkers. The stories can be either fact or fiction, educational or entertaining, and relayed in writing, verbally or visually. You share your stories with friends, family, clients, students, coworkers, online, in your journal or with your fans/followers. Your stories go beyond self-promotion for their value and impact.

THE TEACHER

You are a born instructor and enjoy passing on your knowledge and experience to others, and are skillful at helping your students (or clients, coworkers, etc.) to understand new material. People look to you for answers, and you're able to provide them.

THE VISIONARY

You are an agent for change. You are called to make a difference either within your immediate community or within society in general. You have ideas for positive transformations. You are shaping the future.

THE WARRIOR

You are not afraid of conflict and you'll fight either verbally or physically. You stand up for yourself and also for others. Some warriors have a quiet strength about them, and some have loud warrior energy. You are assertive.

THE WRITER

You have always been deeply connected to words and feel most comfortable expressing yourself in writing. You write journals, blogs, articles or write for your job. Your writing can be fiction or non-fiction. You also enjoy reading other people's writing.

SEE IT IN ACTION!

Go to vimeocom/123814460/ea0b914b89 to watch a video of Sarah creating this journal page.

THE MYSTIC
Sarah Trumpp
Mixed-media art journal page with Yarka watercolors, Daler-Rowney pearlescent liquid acrylic ink, PanPastels, Mod Spirals stencil by The Crafter's Workshop and Krylon Workable Fixative.

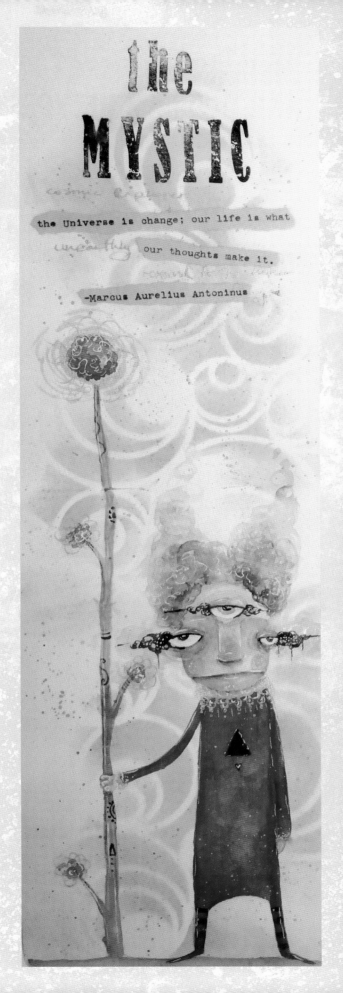

The MYSTIC

the Universe is change; our life is what our thoughts make it.

-Marcus Aurelius Antoninus

INSPIRING ARTISTS AND THEIR ARCHETYPES

At this point you may be thinking, "Well this is all fascinating, but how do I apply it to my art journaling?" The following pages will introduce you to seven professional artists—lovely, soulful beings who focus on their archetypes as subjects or inspiration for their art journal pages. Reading about their guiding archetypes will show you how they are in alignment with their true selves. Be sure to check out their classes, websites and blogs—you'll learn a lot and be inspired.

NATHALIE KALBACH

NATHALIE KALBACH

Nathalie Kalbach is a self-taught mixed-media artist. She was born in Germany and lived there most of her life before moving to the United States in 2013. She has taught workshops in Europe, Canada, the United States, Australia, Israel and Malaysia, as well as countless online courses. Nathalie loves to share what she knows about tools, supplies and techniques—all with the goal of helping each student unlock his or her personal creativity.

Her artwork is licensed through StencilGirl Products (stencils) and Stampendous (rubber stamp and template sets), and has also been featured on the packaging for Liquitex acrylic painting sets. She is a product development consultant to several art and craft supply manufacturers. Visit her website at nathaliesstudio.com.

Nathalie's guiding archetypes include:

 The Artist – Nathalie is a self-taught mixed-media artist. She has her own lines of stencils and rubber stamps.

 The Teacher – She offers online and live classes on art journaling and mixed-media art techniques.

 The Mentor – She assists students with figuring out how to make a living from their passion.

 The Pioneer – She moved from Germany to the USA and created her own business her way.

 The Rebel – She works for herself, which is against the status quo. She doesn't follow trends in lifestyle or in art.

 The Judge – Nathalie believes in a balance of power, and that there is a right way and a wrong way of doing things. She analyzes art and is also critical of people who want to be successful but aren't willing to put in the "sweat equity." She was a paralegal for seventeen years.

 The Liberator – Through her classes, she frees others to get in touch with their artistic selves—especially with her Creative JumpStart class.

 The Comedian – Nathalie's classes are light-hearted, and she is always quick with a joke.

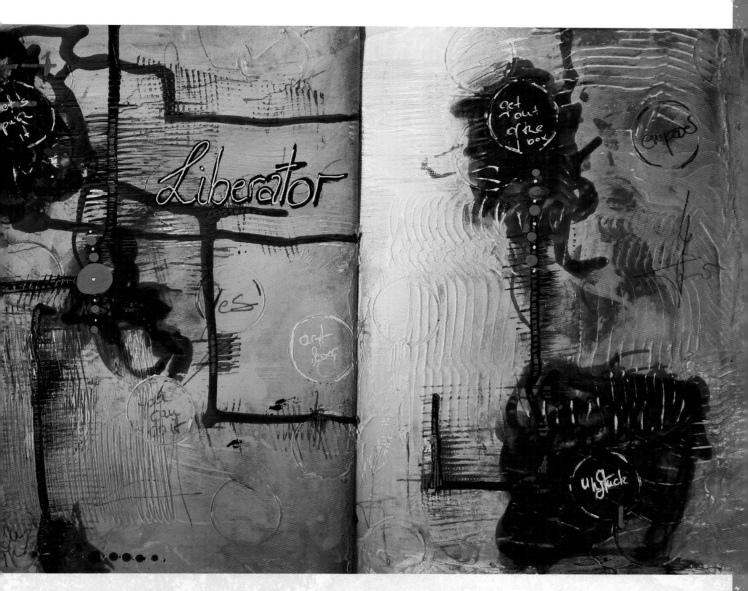

NATHALIE KALBACH ON HER ARCHETYPAL INFLUENCES

"I teach other mixed-media artists, aspiring artists or hobby artists how to express themselves and I empower and liberate them to move beyond being stuck in the creative process (Artist and Liberator).

Coming from a very different career path as a paralegal (Judge) and taking the risk of changing my career (Pioneer), I understand the struggles of undertaking the creative path.

I feel it is important to do what you like and what you are good at. For me, creating art is a dialogue between my skills and the supplies I use. It is not so much a battle as an ongoing attempt to work out the connections between ideas and techniques (Judge).

I know how to listen to my students and how to help them let go of their inner critics (Teacher). I strive to make my students feel comfortable and give them guidance (Mentor) by making sure they embrace their different and individual styles (Rebel).

I love to crack a joke to lighten up the situation (Comedian) and emphasize in my classes to enjoy the moment and the process of art-making. I believe everyone can be creative!"

THE LIBERATOR
Nathalie Kalbach
Mixed-media art journal page with gesso, ink and acrylic paint.

SEE IT IN ACTION!

Visit nathaliesstudio.com/2015/03/19/ playing-with-gesso-and-acrylic-ink to watch Nathalie Kalbach make a similar art journal page using the same techniques.

ORLY AVINERI

Orly Avineri studied fine arts in an artists' village nestled at the foot of Mount Carmel in Israel, and later went on to study graphic design at HKU University of the Arts Utrecht in the Netherlands. She is passionate about the process of marrying multiple media to create a unique visual experience for both the eye and the spirit. Orly is the author of *In My Bones: A Visual Journal* and *14 Artist Journals.* Her artwork has been published in the books *Paint Mojo, The Pulse of Mixed Media* and *Personal Geographies,* as well as in *Art Journaling* and *Artful Blogging* magazines. Visit her website at oneartistjournal.com.

ORLY AVINERI

Orly's guiding archetypes include:

The Visionary – Orly sees art as a way to get to the essence of one's humanness, and she wishes to share this passion. She comprehends the connection between creativity, humanity and nature, and is working towards bringing this awareness to others.

The Storyteller – Her art journals tell stories. During workshops, she is more storyteller than typical teacher. She is enamored with words and takes every chance she gets to accompany her visual stories with her written expressions.

The Liberator – In her classes, she prefers to take her students to a new level of relating with the art materials and reflecting on their personal lives over teaching them step-by-step lessons. Her classes are more process oriented than results oriented.

The Artist – Orly prefers the term "The Creative" because it's less restrictive and encompasses more of who she is. The visual language is her preferred language to express her world.

The Warrior – She is a strong believer in speaking up to advance individual and collective ideas of love and unity and in resisting any form of oppression.

The Rebel – She independently published three books. It's important to Orly that whatever she chooses to create is aligned with her personal vision, her nature, her experiential pool and her creative sensibilities, uncompromised by outside considerations.

The Pioneer – She grew up in Israel, lived in the Netherlands and now resides in Southern California. She continuously challenges stagnant ideas of art and life while exploring new processes of creation, innovative giving and living life passionately. She agreed to be part of this book because she was attracted to the "new territory" she would venture into.

The Nature Gal – Orly is rooted in and deeply connected to the Earth. She sees a direct connection between nature, art and humanity. Her workshops are often in natural settings, and nature can often be found in her artwork and the material she teaches.

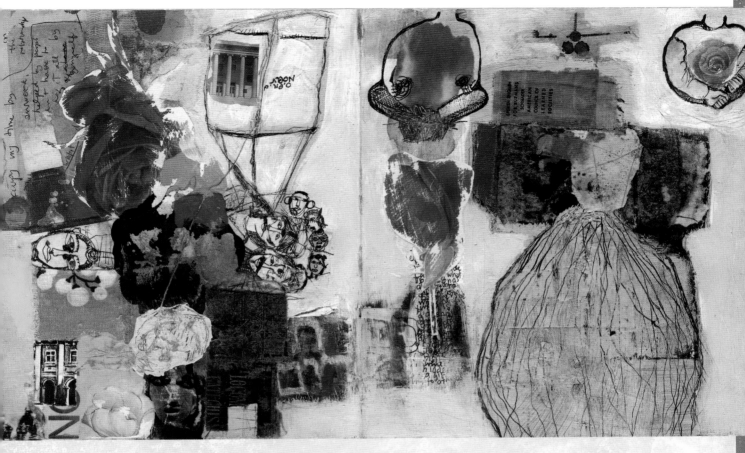

ORLY AVINERI ON HER ARCHETYPAL INFLUENCES

"I make art in books. I notice that I consider my pages to be complete when at least one of my archetypes emerges from total anonymity to full visibility. Very often I find traces of all of them in one page. It makes complete sense to me now. The Visionary, Storyteller, Liberator, Creative, Warrior, Rebel, Pioneer and Nature Gal in me all make appearances on my behalf when needed. In return I give them 'voice' through my visual expression and the connections that I allow myself to have with the world and all that binds us together."

THE STORYTELLER
Orly Avineri

Mixed-media art journal page with acrylic paint, pen, collage paper, carbon paper, sandpaper and peelings.

ORLY'S ARTISTIC PROCESS

Repeat all steps until your archetype(s) naturally emerge from your pages. Add and omit to support the materializing image.

- Acrylic paint: While the paint is still wet, make random marks with unconventional materials like an awl or pizza cutter, rubber bands, branches, your fingernails, etc. Use organic brush strokes, smear with paper towels and swish the paint around with your hands.

- Collage: Distress papers, pieces of fabric, old anatomy images, bits of old fabric, book covers, old personal letters and notes. Glue them down using Matte medium for heavier papers and Matte Gel for lighter papers.

- Copy/Carbon paper: Trace and treat representational images like tribal wooden statues and masks.

- Sandpaper: Remove and unite layers by sanding and creating texture to reveal what's underneath.

- Peelings: Peel off parts of the collage elements and glue them down in other areas.

- Pen: Add lines, draw, doodle and outline to define certain areas that need to come forward.

SARAH TRUMPP

SARAH TRUMPP

Sarah Trumpp is a self-taught mixed-media artist, sculptor and fiber artist. She lives in the wilds of rural New York with her family, menagerie of pets and hoard of art supplies. Sarah has taught in several collaborative online workshops and in-person art retreats. She has most recently launched her own online learning portal.

Sarah's greatest passion is being the vehicle for inspiration for her students, giving them room to find their own voice and feed their own weird. She is constantly looking for tips and tricks she can pass on so that everyone can find more time for more art.

Sarah recently started her own line of stencils, which she designs, produces and distributes out of her mad scientist's laboratory. She teaches art techniques at her YouTube channel, Wonderstrumpet. Visit her website at wonderstrange.com.

Sarah's guiding archetypes include:

 The Mystic – Sarah's spiritualism comes from a connection to Earth, goddesses and other ancestral deities. This connection sustains her and she checks in with it often.

 The Lover – She has a big heart and accepts all people. Just don't be a jerk to her, and she'll be your best friend.

 The Mother – She has three kids and loves every awesome, gross, loving thing about being a parent. She structured her career around raising a family.

 The Artist – She actually prefers the term "The Creative" because it comprises all the ways she expresses herself. Besides creating art, she also sings and plays the ukulele and the flute.

 The Comedian – If you watch Sarah's videos or read her blog and social media posts, you'll witness her humor and witty sarcasm. Her artwork is a blend of noir and whimsy. It will put a smile on your face.

 The Student – If she isn't taking a new class, then her nose is in a book learning something new.

 The Teacher – She loves passing down her knowledge, and teaches art techniques on her YouTube channel.

 The Detective – She is a volunteer firefighter. She is also a bit nosy sometimes.

 The Hermit – For all the love and energy she gives out, Sarah is actually an introvert and is in her happy place when alone.

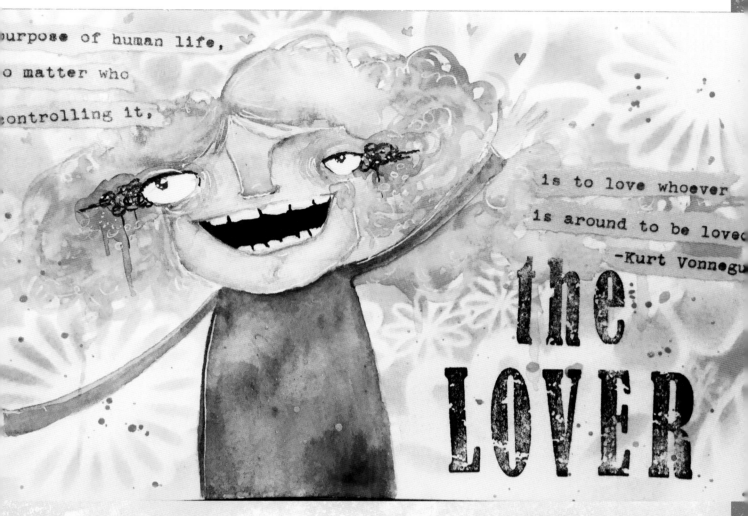

purpose of human life,

o matter who

controlling it,

is to love whoever

is around to be loved

—Kurt Vonnegut

the LOVER

SARAH TRUMPP ON HER ARCHETYPAL INFLUENCES

"At my core, I am a Lover—open-minded and wanting joy for the world. My Mother aspect plays into that fully and powerfully with a need to shelter and protect that joy. As a Creative, I try to bring joy into my own life and the lives of friends and strangers alike, often calling upon my Comedian to bring laughter into my music, art and writing. As a Teacher, I try to pass on what wisdom and skill I've developed through my time as a continual Student, using my Detective aspect to take things apart and figure them out before passing that knowledge on.

Underlying all of these seemingly extroverted behaviors lies the soul of a Hermit. I use my deep-seated Mystic and the belief of interconnectedness of all things to sustain me when I feel the need to retreat, especially when I am unable to. That spiritual connection helps to supply the energy and will needed to support my more outgoing aspects."

THE LOVER
Sarah Trumpp

Mixed-media art journal page with Dr. Ph. Martin's Bleed Proof White ink mixed with water, vintage letters stamps by Stampendous with StazOn ink and the Flower Frenzy stencil by The Crafter's Workshop.

SEE IT IN ACTION!

Visit vimeo.com/123816129/150e33c703 to watch a video of Sarah creating this journal page.

JESSICA SPORN

Jessica Sporn is a former actress and lawyer turned full-time artist. Her style is colorful and ranges from whimsical to spiritual. An internationally licensed illustrator, she designs stencils for StencilGirl Products and stamps for RubberMoon Stamps. She also creates designs for Aviv Judaica, Inc. She hosts a successful monthly meet-up group in her Montclair, New Jersey, studio and has taught at The Ink Pad in New York City and Art Is You Mixed Media Art Retreats. Jessica is represented for licensing by Creative Connection, Inc. Visit her blog at jessicasporn.blogspot.com.

Jessica's guiding archetypes include:

The Mystic – Jessica has a deep connection with God/Source and believes she is doing work as a vessel of this connection. She is also a 500-hour certified yoga teacher.

The Mother – She has two children of her own, is godmother to a Mayan Guatemalan boy and also has a foster son, whom she welcomed into her home after his mother passed away.

The Queen – She manages, runs and coordinates her art business, her family and her charitable work. She finds herself in leadership roles because she's organized and will get it done.

The Teacher – You can find Jessica at art conferences and watch her videos on YouTube. She also offers online classes, such as the popular Embrace Your Inner Art Goddess.

The Artist – She is an illustrator, art journaler and greeting card designer. She has a line of stencils through StencilGirl Products and a rubber stamp line through RubberMoon. Her bright and colorful art prints, canvases and cards are for sale on her website.

The Advocate – She does volunteer work in Guatemala through From Houses to Homes and organizes art auctions to raise funds for a variety of causes. She was also once a lawyer with an interest in reproductive rights.

The Performer – An actress from the get-go, Jessica attended New York City's High School of Performing Arts. She continues to act with her community theater and has always enjoyed relating to an audience.

The Nature Gal – She has a summer cottage on a lake and she must have outdoor space. Bits of nature can often be found in her art.

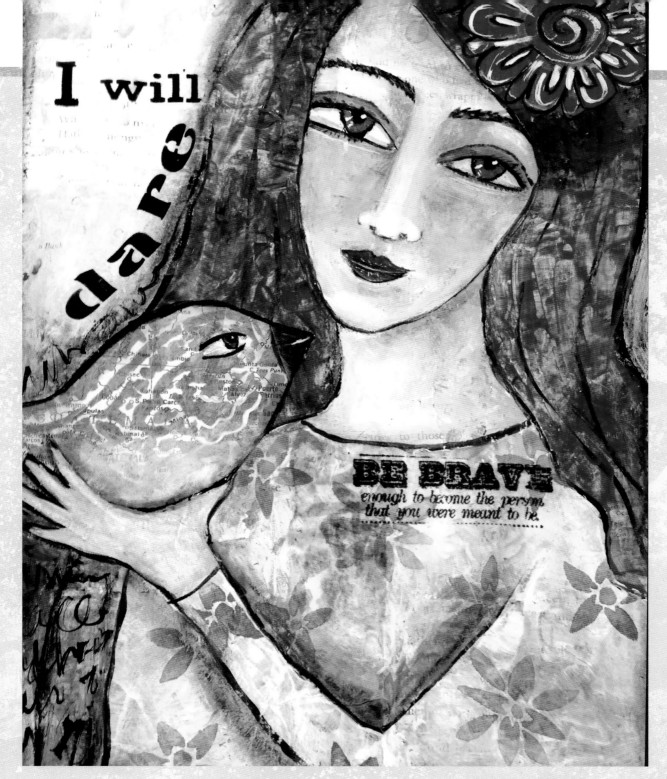

JESSICA SPORN ON HER ARCHETYPAL INFLUENCES

"I feel authentic and at peace when I'm creating and teaching others art. Teaching art also feeds the Performer in me. For me, there is no distinction between my work as an Artist and my roles as a Mother, Teacher and Performer. I love using my art to reflect and Advocate for causes I feel strongly about. In all of these roles, I feel a deep connection with my divine spirit. This mystical connection sustains and guides me. I also feel truly grounded in and around nature. When I'm outside, especially near water, my Nature Gal and Mystic are in true alignment, and I feel a oneness with all creation."

THE BIRD WHISPERER
Jessica Sporn
Mixed-media art journal page with Golden fluid acrylics, Liquitex matte medium, oil pastels, fragments of old texts and maps and Jessica's Paisley stencil. This page was inspired by Jessica's Mystic, Nature Gal, Mother and Advocate archetypes.

MARY BETH SHAW

MARY BETH SHAW

Mary Beth Shaw worked in the insurance industry for eighteen years before she quit her job in 2000 to re-ignite a childhood love of art. She is now a full-time painter and internationally known workshop instructor. Her creative process is largely self-taught, spontaneous and joyful. She is the author of *Flavor for Mixed Media* and *Stencil Girl* and a columnist for *Somerset Studio* magazine.

In 2010, Mary Beth recognized a need for artist-designed stencils and created StencilGirl Products, which has quickly grown into a respected supplier of high-quality stencils for all media. Visit her website at mbshaw.com.

Mary Beth's guiding archetypes include:

The Mother – Mary Beth's students and customers love her nurturing and caring presence. She is also a "mom" to three furry cats.

The Storyteller – She holds a degree in journalism and includes a lot of writing in her artwork, even though it's hidden and subliminal. Nothing fascinates her more than words. Check out her blog for some snarky stories in addition to art instruction.

The Liberator – With her products and workshops, she hopes to enliven the creativity in others. She facilitates classes so students can find their own voice.

The Artist – She is a mixed-media artist and has authored two art instruction books.

The Detective – Mary Beth used her investigative skills working in insurance claims for eighteen years. Now she uses these same skills to figure out what products her customers need and want.

The Queen – She has always been a high achiever and a leader. She's the "Queen Bee" of her business.

The Entrepreneur – Mary Beth is the creator and owner of StencilGirl Products. She enjoys business development and figuring out the next trend for sales.

The Lover – She has a bumper sticker that says, "Coexist," which pretty much sums up how she views individuals, society and humanity.

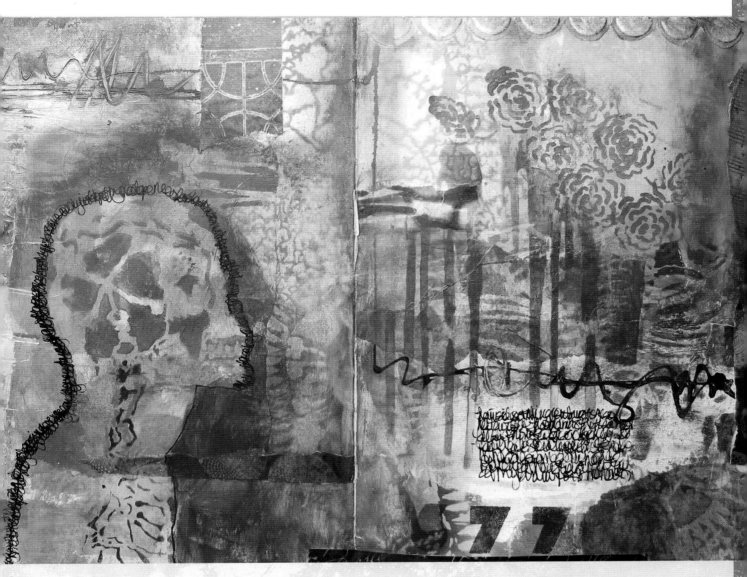

MARY BETH SHAW ON HER ARCHETYPAL INFLUENCES

"As a visual Artist, I believe life is a mixed-media adventure. I primarily use my own art as a component of Storytelling, be it with a collector, audience or students. It is my great hope that the art and stories I share will help others move toward personal Liberation.

"On a personal level, I seek peace internally and in those around me. I find it important to facilitate a life where everyone gets along and respects one another. I believe that we each have a choice in how we live and I choose to always come from a place of Love. This love of all things manifests in my Mother tendencies toward family and animals. Professionally, I am a Queen but also have a strong Detective bent. These qualities serve me well as an Entrepreneur."

BIRTH OR REBIRTH
Mary Beth Shaw

Mixed-media art journal page with paint, gesso, white pen, Posca markers, Inktense pencil, Matisse Pam Carriker's Fluid Matt Sheer Acrylics, Jo Sonja Artists' Colours, and Subliminal Skull, Splats, Blooms and Bones, and A Skeletal Plot stencils by StencilGirl. This page was inspired by Mary Beth's Artist archetype.

SETH APTER

SETH APTER

Seth Apter is a mixed-media artist, instructor, author and designer from New York City. His artwork has been exhibited in multiple exhibitions and can be found in numerous books, independent zines and national magazines. He is the voice behind The Pulse, a series of international, collaborative projects that are the basis of his two books, *The Pulse of Mixed Media* and *The Mixed-Media Artist.* He also has two workshop DVDs: *Easy Mixed-Media Surface Techniques* and *Easy Mixed-Media Techniques for the Art Journal.*

Seth is an instructor at Pratt Institute in New York City, and his live workshops have been held throughout the United States, Mexico, Australia and the UK. He has a mixed-media line with Spellbinders paper arts, a stencil line with StencilGirl Products and a stamp line with Impression Obsession. He is a member of CHA and a columnist for *Cloth Paper Scissors* magazine. Visit his website at sethapter.com.

Seth's guiding archetypes include:

 The Healer – Seth is a psychologist and has been in private practice for many years. His specialty is working with stroke survivors and medical conditions such as traumatic brain injury.

 The Mentor – He enjoys helping people uplevel their lives and create a life from their passions. He also mentors psychology graduate students.

 The Father – Seth brings warmth and encouragement to his students and clients. He cares deeply about them.

 The Artist – He is a mixed-media artist who relishes mail art, art journals and abstract work. He has two mixed-media techniques DVDs and teaches classes across the USA and worldwide. He has his own lines of mixed-media stamps and stencils.

 The Scribe – His books, *The Pulse of Mixed Media: Secrets* and *Passions of 100 Artists Revealed*, are the products of his gathering information, synthesizing it, and having a record of 100 artists for others to learn from. He also was once a research coordinator.

 The Entrepreneur – Seth has a variety of products and business development ideas. He has been able to combine all his passions and make an authentic living.

 The Performer – He is an actor and has performed on stage as well as in commercials. Now he enjoys being in front of an audience of workshop attendees.

 The Networker – He is a natural at connecting people within his communities. Even his books connect people.

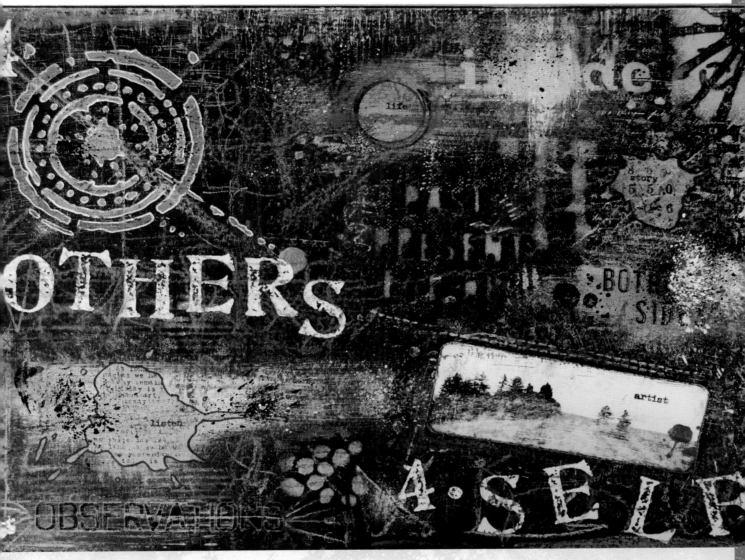

SETH APTER ON HIS ARCHETYPAL INFLUENCES

"Much of my energy is directed toward others: As a Healer, I provide curative help to those in pain or need. As a Father, I offer nurturing, care-giving and quality time to those in the role of 'children.' As a Mentor, I offer guidance and frequently check in with others.

"I am also a Networker. I enjoy being around others, connecting people together and creating community. This emphasis on others is also sustaining for me as a Performer—a role that provides me with comfort and energy.

"The creative side of me is expressed through being both an Artist (seeing all things through an aesthetic eye) and a Scribe (gathering and visually synthesizing information to share with others).

"All of these characteristics successfully blend with my other side as reflected in being an Entrepreneur."

4 OTHERS, 4 SELF
Seth Apter

Mixed-media art journal page with black and white gesso, oil and wax pastel crayons, black and white gel pens, water- and paint-based markers, acrylic paint, altered photographs, rubber stamping, stencils and rub-ons. This page was inspired by Seth's Artist, Entrepenuer, Networker and Performer archetypes.

TAMARA LAPORTE

TAMARA LAPORTE

Tamara Laporte is a celebrated mixed-media artist and art teacher who has been running her own creative business since 2008. She believes that the act of creating art can be a gateway into healing and personal growth—often her art classes contain an element of self-development as well as learning art techniques.

Tamara is the inventor and creator of Life Book, a year-long art course that includes some of the most celebrated mixed-media and personal development teachers out there. Since its inception, it's been joined by more than 8,600 people.

Her artwork and articles have been published in several art magazines and books, and she's been interviewed for several online radio stations. She runs a variety of popular art classes on her Willowing network, which has more than 20,000 members and grows by about 150-200 mixed-media enthusiasts each month. Visit her website at willowing.org.

Tamara's guiding archetypes include:

The Engineer – Tamara is a natural-born problem solver and likes systems to create an easy work flow.

The Artist – Her style is described as mixed-media folk art with a focus on "magical realism." Love, mystery, innocence, hope, spirituality, kindness and self-connection inspire her art. She sells prints, postcards and originals. She also has her own line of stencils through Artistcellar.

The Comedian – If you watch any of Tamara's videos, you will smile because she often has an intro that is quirky, sweet and funny. Often her artwork has elements of whimsy, and she balances the seriousness of her work with lots of humor.

The Queen – Tamara created and runs her own business. She manages a staff and takes her responsibilities seriously.

The Teacher – She has many online classes, but she also teaches live classes. Tamara is very good at breaking down mixed-media techniques for her students.

The Liberator – She is called to reduce/free people from suffering. Her Life Book project not only teaches people new art techniques but also helps them heal, reflect and move forward.

The Mother – Tamara is a mother of two but also brings the mothering aspect of herself to her classes, forums and social media posts.

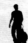

The Rescuer – Tamara wants to alleviate suffering in the world.

SEE IT IN ACTION!

Visit youtu.be/ZiLG5olAoLc to watch Tamara demonstrate the paint-over-collage technique.

TAMARA LAPORTE ON HER ARCHETYPAL INFLUENCES

"The suffering of others impacts me in a variety of ways, which means I have taken on many Rescuer characteristics. I like to help where I can to make the world a more joyful place. I like to help others feel at ease, so I often take on a Comedian role when I teach. I incorporate both helping and humor into my work, calling on inspiring quotes and adding whimsical, quirky beings to my paintings. This approach also Liberates people to become less fearful and be the best versions of themselves. I run my own business and am very committed to being an inspiring, caring, compassionate role model to those who follow my work. My Engineer guides me to inputting systems that allow for a seamless, organized work flow."

MOTHER ART JOURNAL PAGE
Tamara Laporte

Mixed-media art journal page with acrylic paint, watercolor crayons, mechanical pencil, charcoal pencil, white gesso, white Posca pen, Faber-Castell Pitt artist pen, collage paper, scrapbooking paper and book paper.

part 2
SUPPLIES

When visiting online forums and social media pages for art journaling groups, you'll notice that most people seem to gravitate towards mixed-media art and like to work with a variety of materials. Maybe that's because you can be free in an art journal. You don't have to hold back, or deprive or edit yourself. Arrt journaling supplies also tend to be relatively inexpensive, which makes it easy to experiment with various techniques, layouts, themes and materials.

Of course, you could use a single medium throughout your journal. I've seen art journals that are only collage or watercolor. In this book, though, our primary focus will be on mixed-media art journaling.

Almost anything can be used when creating your art journal pages. Here's a short list:

- paints, pens and markers
- rubber stamps and stencils
- used postage stamps
- sequins, stickers and embellishments
- flowers, sticks and leaves
- tea bags
- India ink
- newspaper, dictionary pages and magazine cutouts
- cocktail napkins, tissue paper and wrapping paper
- fabric or cut-up pieces of a canvas painting
- artist trading cards
- children's artwork
- greeting cards and postcards
- any and all ephemera

WHAT TO WORK ON

To really explore art journaling, we first need to chat about the types of journals you can use. There are many options available, spanning a variety of qualities and price ranges. Explore and experiment with different brands and sizes to see what works best for you. Whatever you decide on, I do highly recommend using a journal that has heavy watercolor paper so it can handle all the materials—glue, paints, ink sprays, etc.— you'll use in it.

An alternative to using a bound journal is to use single sheets of paper. I like working on loose sheets because they are light and not bulky, making them especially convenient when I'm traveling, or if I need to adjust the position of the page by flipping it around.

I usually use a binder clip to hold my loose pages. I like to keep them easily accessible because I will often take a page out to hang in my studio or pass around in a class. Also, if you are planning on scanning images, single pages are easier to scan than a bound journal.

CHOOSING AN ART JOURNAL

I like Strathmore's Visual Journals because they are available in two sizes: 9" × 12" (23cm × 30cm) or 8" × 5 ½" (20cm × 14cm). These spiral-bound journals allow you to have the journal open to a single page, hiding the opposite page so it can remain fresh for another day. Be sure to get the 140-lb. (300gsm) watercolor journal. There is a 90-lb. (150gsm) option, but I don't think it's strong enough for mixed media.

I also use an art journal by Dylusions. This large journal is approximately 8" × 11" (20cm x 28cm), and the heavy pages have two different textures. The binding allows the journal to open and lay flat without any bumpy spiral, which is convenient when working on a two-page layout. There is also an outer band to hold it together securely and a large envelope to collect and hold items for use in the future.

All of these journals have rigid covers to protect the inside pages from ripping or curling.

CHOOSING PAPER

If you prefer not to use a bound journal, try loose sheets. I do not have a brand preference for loose paper, just as long as it is heavy.

The pad with the brown cover is 140-lb. (300gsm) mixed-media paper by Strathmore. The pad with the blue cover is 140-lb. (300gsm) watercolor paper by Canson. The textures are slightly different, which would only be of concern if you were going to create watercolor paintings. But both textures work well for mixed-media art journaling.

BINDING PAGES

After you have completed a set of single pages, you may want to bind them together. There are a few options for this:

- hole punch each page and then use circle binder clips (also called snap rings) to hold the pages together

- hole punch each page and tie off with yarn

- sew a small stack together, either by hand or with a sewing machine using a zigzag or straight stitch

MAKING YOUR MARK

The following is just a brief list of supplies you can use for mark-making in your art journal pages. Have fun exploring the various effects you can achieve by combining them.

MARKERS, PENS AND PENCILS

- **Copic markers** – I like the square variety because they fit in the Copic Airbrush System. This style comes with a chisel tip and a fine tip.

- **China markers** – Also known as a grease pencils, I use these a lot because they provide waxy, textured marks. If you get a black one, I advise you to also pick up a white one.

- **Letraset AquaMarkers** – These are water-based markers with fine and thick brush tips.

- **Montana markers** – These markers contain permanent acrylic paint and come in five tip sizes from extra fine to extra broad. With the broader sizes, you can create drips by pressing hard and holding your journal vertically so the paint can glide down the page.

- **Portable watercolor brushes** – The top of a portable watercolor brush unscrews, and the body is filled with water. They can be used with watercolor pencils and watercolor blocks. My set is by Aqua Flow and it came with three different sizes of tips.

- **Prismacolor art markers** – These markers have a broad chisel tip that is great for wide strokes. The other side has a fine point, good for details, outlining and lettering.

- **Sharpie makers** – I love my Sharpies, especially the ultra-fine-tipped ones. They are great for detailing. The thicker tips work well for outlining.

- **Watercolor blocks** – These can be used the same way as watercolor pencils—with one additional benefit. With the blocks, you can take a wet paintbrush, lift color off the block and paint with it. Blocks are usually used for backgrounds or when you need a lot of color in one area. I use Inktense Blocks by Derwent because I like how bright and saturated the colors are. Once the watercolor dries, the color becomes permanent and can be worked over without changing the bottom layer.

- **Watercolor pencils** – I use the brand Prismacolor. I haven't tested a lot of different brands because I don't go through these quickly. These are used for detail work and outlines. Watercolor pencils can be used dry or wet. There are a few ways to use wet. You can draw on the

MAKE YOUR OWN MARKER PENS

If you wish to make your own marker pens, try Molotow empty pump-markers. They can be filled with any liquid paint, but remember—not all paint is created equally. I usually use a high-flow paint by Golden, but the One4All paints by Molotow also come highly recommended. They are highly pigmented and solvent free.

paper, then use a small wet brush to activate the color. Or you can dip the pencil in water and use it. This will produce a bolder and brighter line. Lastly, you can wet the paper first, then use a pencil over the top. The color will bleed.

- **White pens** – This very simple implement can add so much to a page, especially a page painted black, gray or dark blue. The contrast makes the white ink pop. I use a Uni-ball Signo pen. I've tried a few others and end up having to toss them out because of clogging or not being bright enough.

MARK-MAKING TOOLS

1. *Watercolor pencils*
2. *Prismacolor art marker*
3. *Montana marker*
4. *Letraset AquaMarker*
5. *Copic marker*
6. *Fountain pen*
7. *Uni-ball Signo white pen*
8. *Sharpie marker*
9. *Portable watercolor brush*
10. *Ballpoint pen*
11. *China markers*
12. *Watercolor blocks*

BRUSHES

As much as I enjoy pens, pencils and markers, I also use paintbrushes a lot in my art journaling. I believe you can never have too many brushes, but if you're just starting out, there are only a handful you'll need. I recommend the following brushes:

- fan
- angle
- liner
- no. 4 or no. 6 filbert
- no. 8 flat
- no. 12 flat

Or, you could go to the art supply store and pick out a starter brush set for acrylic paint. I do recommend getting a moderately priced set, because super cheap brushes shed bristles and don't hold paint as well. It's frustrating, and you may just end up throwing them away. So it's definitely worth it to invest a bit more in your brushes up front.

BRAYERS

Brayers are most often used to apply paint and gesso. They are useful for applying wide swaths of color and creating rough textures. Brayers come in a variety of sizes. They also work great on a Gelli Arts Gel Printing Plate. (See the Gelli Plate Printing demonstration in Part 3.)

MY (INCOMPLETE)
BRUSH COLLECTION
This is just a tiny sample of brushes I use, along with one of my favorite tools of all time—the brayer.

I favor using glass jars to hold my water. Pickle jars work well because of the wide openings. (Just make sure you run them through a dishwasher a few times before using!)

BRUSH CLEANING TIPS

Take this pledge:
I promise to love and honor my brushes and not let them sit in water for days or weeks. I know this can alter the shape of the bristles, loosen the ferrule, and paint could harden on them. I also need my brushes clean and ready for action!

Now that you've made a promise to your brushes, they will last a lot longer. Just like everything else in life, it's best to clean as you go. Soap and water usually do the trick. But if paint has hardened on your brushes, you can try:

- nail polish remover
- hand sanitizer
- The Masters Brush Cleaner and Preserver

BRING ON THE COLOR

We've covered watercolor pencils and watercolor blocks, but there are other options for adding color to your journal pages. If you were working on a professional painting, the materials would need to be UV protected. However, for your personal art journal, use whatever catches your eye. I often use odd materials like nail polish, makeup, pomegranate juice and tea bags.

- **Acrylic paint –** I typically use Golden paints, because the tubes don't dry out and the colors are vibrant. But premium paints do not need to be purchased for art journaling. There are many student-grade tube paints and craft paints that are more economically priced.

- **Craft paint –** Ninty-nine cent paints that you can sometimes get for fifty-nine cents? Yes, please! The price point of these bottles allows for freedom and exploration, since the investment isn't high.

- **Fluid acrylics –** These are great for pouring, brushing or staining.

- **Golden Acrylic Glaze –** This is used for washes or hints of color, especially for top layers.

- **High-flow paints –** These paints by Golden are perfect for creating drips and splatters.

- **Inka Gold by Viva Décor –** These create a metallic finish without any harmful chemicals. Beeswax is one of the main ingredients; it has a thicker texture. Apply with a sponge, brush, your fingers or a paper towel. Just rub it on! They come in gorgeous colors and they're water resistant.

- **Ink sprays –** Used for backgrounds or with stencils. Dylusions ink sprays are great because they are highly pigmented and come in beautiful colors. Plus, the creator Dyan Reaveley is a hoot! Watch her videos for cool ink spray techniques. (Seriously, she is really funny.)

- **Silks Acrylic Glaze by LuminArte –** These are shiny glazes. They have a semi-gloss finish due to mica being mixed in. Since they are translucent, you can layer them after they dry. But I like applying them over opaque acrylics. Apply with a brush, rubber stamp, sponge or palette knife.

- **Spray paint –** You can cover a background swiftly with spray paint, or make a graffiti-like puddle or splat. I get the mini cans because I prefer to have a variety of colors, but I don't use them every day.

- **Tim Holtz Distress Paints –** These are created by Tim Holtz and sold by Ranger. I like the size of the bottles

PAINT SUPPLIES

Back row from left to right: Golden high-flow acrylic paint, Dylusions ink spray, Golden Acrylic Glaze, Krylon webbing spray, neon craft paint, Tim Holtz Distress Paint.

Front row from left to right: Golden tube acrylic, Inka Gold by Viva Décor, Silks Acrylic Glaze by LuminArte and Golden fluid acrylics.

and I love the dabber on top. You can color a whole page, or use them around edges or to add color here and there. They also work well with stencils. The colors are distressed, so they are a bit muted compared to high-flow paints. It's acrylic, so once dry, it won't be activated if another layer of paint or water is applied.

- **Webbing Spray –** This spray paint comes out looking like spider webbing. It can make cool backgrounds. It can also be used to create a cloudy mood.

- **White paint –** When buying white paint, make sure you're getting the white you want. Titanium White is an opaque bright white. When you want to paint something white, this is what you need. When mixed with a color, it will lighten that color. Zinc White (also called mixing white) is transparent and is more of a hint of white. It's used when mixing skin tones. Titanium White is what you want to use when mimicking light reflections; Zinc White will be too weak.

QOR WATERCOLORS

These lovely modern watercolor tubes are unlike any others I've tried. They have an exclusive binder that provides more pigment per brushstroke, and the vibrant colors are more brilliant than other watercolors I've used. QoR Watercolors (pronounced "core") can be used in the traditional way with a brush and water, but they really pack a punch when applied straight from the tube without water. Leave as is or scrub with a towel.

PANPASTELS AND SOFFT KNIVES

Need another option for color? Try PanPastels for a soft effect. These are an alternative to soft pastel sticks. They come in pans that are stackable or can be held in specially made trays. They are low-dust, but you will still need to apply a fixative spray when your page is completed. The colors can be layered and applied with makeup sponges or with Sofft Knives, as shown in the photo. Sofft Knives come in a variety of shapes and covers. PanPastels work great with stencils, too.

CREATING ADDITIONAL EFFECTS

If you want to spice up your journal pages, the following supplies are great for adding extra effects:

- **Black gesso** – Can be used to create a moody background or a night sky.

- **Clear gesso** – Adds texture but not color. It looks great over a collaged page.

- **Clear Tar Gel** – Makes drippy stringy effects like Jackson Pollock.

- **Glass bead gel** – Creates a coarse, luminous effect. It's really cool for beach scenes.

- **Mod Podge** – Works well for collaging.

- **Wax paper and deli craft paper** – Can be used with your Gelli plate to create prints and as collage material with rubber stamping, paint or stencils.

SUPPLIES FOR CREATING ADDITIONAL EFFECTS
From left to right: Liquitex colored gesso, Golden Heavy Gel, Golden Regular Gel, Golden Clear Tar Gel, Golden Glass Bead Gel, Mod Podge and Liquitex clear gesso.

WASHI TAPE
Washi tape can be used:
- *to frame an image*
- *under a layer of gesso for texture*
- *to color in an image such as a dress or a bird*
- *to block out text when doing blackout poetry*
- *to create a striped background*

ARCHETYPAL STENCILS

An astrologer regularly thinks about horoscopes. A pediatric nurse naturally thinks about children's health, even outside of the doctor's office. A fiction writer can't hush the storylines, characters and dialogue from creeping into her head. Alas, I can't stop myself from constantly thinking in terms of archetypes. If a dear friend complains about her boss, I ask, "Is she The Queen, The Mother or The Engineer?" I then go on to ask a lot of questions to try to bring clarity to the situation and hopefully help my friend work around that energy. This habit translates into seeing archetypes in everything—people, relationships, movies, books, magazines, advertisements, commercials—even art materials such as stencils.

It took a long time for me to accept using stencils in my artwork because I thought it was somewhat fraudulent to produce art using someone else's creations. However, about ten years ago, I started playing with stencils in a way that didn't feel like I was cheating in my art-making. Rather than using stencils the old-school way of placing them down and coloring images in, I began to experiment with alternate methods and techniques for using stencils. These days I layer them, or use just a corner of one, or cut them up to create eye-catching backgrounds and textures on my art journal pages and canvases.

The materials used with stencils nowadays are far cooler and more varied than what was out there a decade ago. Color can be filled in with PanPastels, spray paint, ink sprays, dabbers and more. The array of stencil designs has also grown—boutique stencil producers wow us monthly with new ideas. And naturally, because I can't stop myself from thinking in terms of archetypes, whenever I see a new stencil line, I automatically connect it to certain archetypes.

Here are a few stencil suggestions to help you with your personal art journal pages. Some stencils may make more sense to you for a different archetype than what I have identified—that's OK! These are just suggestions.

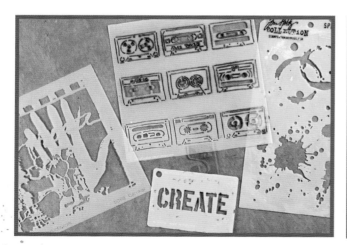

ARTIST

Good for anyone who expresses their soul through the creative arts—visual artists, musicians, writers, etc. From left: Journaling Left Hand by StencilGirl, Mix Tape by The Crafter's Workshop, Splatters by Tim Holtz and Create mini by Artistcellar.

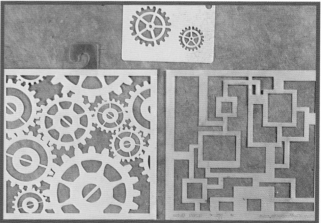

ENGINEER

Good for problem solvers and people who like systems and are highly organized. From left: Apparatus by Artistcellar, Mini Gears by Artistcellar and Blueprints of Archeological Treasures Small by StencilGirl.

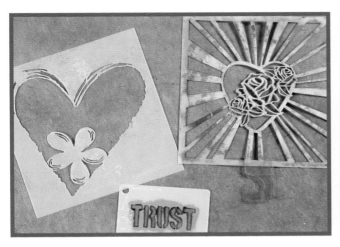

LOVER

Good for those with a big heart and a great deal of empathy, passion and compassion. From left: Heart Flower 6 by StencilGirl, Trust mini by Artistcellar and Immaculate by Artistcellar.

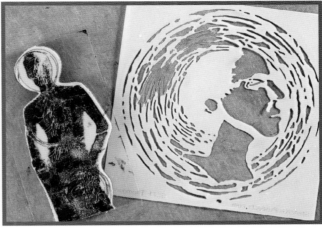

VISIONARY

Good for those who can envision positive change for their community or society at large. From left: Grungy Silhouette cling mount stamp by Dina Wakley (A stamp snuck in!) and Angel Circle by StencilGirl.

NATURE GUY/GAL

Good for people who feel a strong connection to nature and animals. From left: Black Birds in Trees by StencilGirl, Free as a Bird by StencilGirl and Stepping Stone #3 by StencilGirl.

NETWORKER

Good for people who enjoy building connections and relationships, and those who get energized by collaborations. From left: Doodle It Geometric Landscape by StencilGirl, Doodle It Layered Circles and Squares by StencilGirl and Aboriginal by The Crafter's Workshop.

PIONEER

Good for travelers DIY people and pull-yourself-up-by-the-boot-straps types of people. From left: Old World Paris Maps by Artistcellar and Vintage Camper Trailer by StencilGirl.

QUEEN/KING

Good for leaders, bosses and the Queen Bee of the household—people who like to call the shots and take responsibility seriously. From left: Loose Woman #1 by StencilGirl, Sally & Carly by The Crafter's Workshop and Radiant Crown mini by Artistcellar.

CLEANING STENCILS

It's best to clean your stencils immediately after use, especially if you've used paint with them. Let me say that again—it is best to clean your stencils *immediately* because when paint dries, it hardens. This not only makes it more of a challenge to clean a stencil, it also increases the chances of the stencil tearing.

Usually, wiping the stencil down with a paper towel immediately after use will be enough to get the job done. If that doesn't work, try these other methods:

- Soap and water

- Hand sanitizer on a cotton ball

- Nail polish remover (but this could lessen the integrity of the stencil)

- White Magic Erasers

These methods work best for cleaning acrylic paint off stencils. If you use alcohol-based markers, like Copics, you will probably have to clean with a cotton ball and rubbing alcohol.

And what if, after all of that, your stencil is still not clean? Well, then you may just have to live with a beautifully dirty stencil. After all, they are meant to be used!

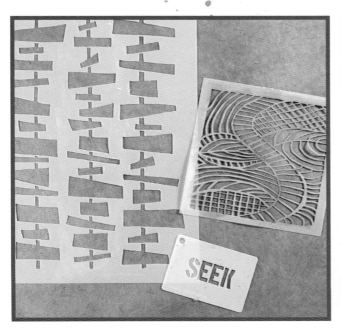

SEEKER

Good for people who are constantly searching for the next truth or next level for themselves. From left: Sign Posts by StencilGirl, Zen Landscape by StencilGirl and Seek mini by Artistcellar.

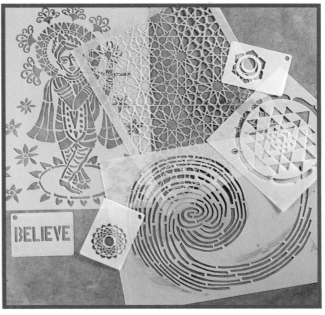

MYSTIC

Good for those who feel deeply connected to their spirituality. From top left around: Krishna Deity by StencilGirl, Celestial by Artistcellar, Sacral Chakra mini by Artistcellar, Sri Yantra by Artistcellar, Spiral by StencilGirl, Crown Chakra mini by Artistcellar and Believe mini by Artistcellar.

STORING STENCILS

Nothing stops the creative flow like having to stop and spend ten minutes searching for that one particular stencil. It's just frustrating. So, having your stencils organized will help you immensely. Really, this is true for all your materials, but stencils are a little trickier because they are delicate bits of plastic that can get tangled up if laid on top of each other. Once they get bent, it's not easy to get them to lay flat again. Some people just pile them on top of each other in a drawer, but I do not recommend this. Others keep them in manila file folders with labels, while others prefer see-through binder pockets. However, if you're like me and need to keep your materials exposed, then none of these options will work for you.

I never know what is going to call to me in the midst of art-making. Therefore, I hang my stencils using plastic hanging hooks that are sticky on the end, and press the hook onto the stencil. The only exception is that anything smaller than 6 inches (15cm), like my mini and pocket stencils gets put in a binder or a small see-through plastic box. All materials for my stencil-hanging setup were purchased at a hardware store and installed in minutes.

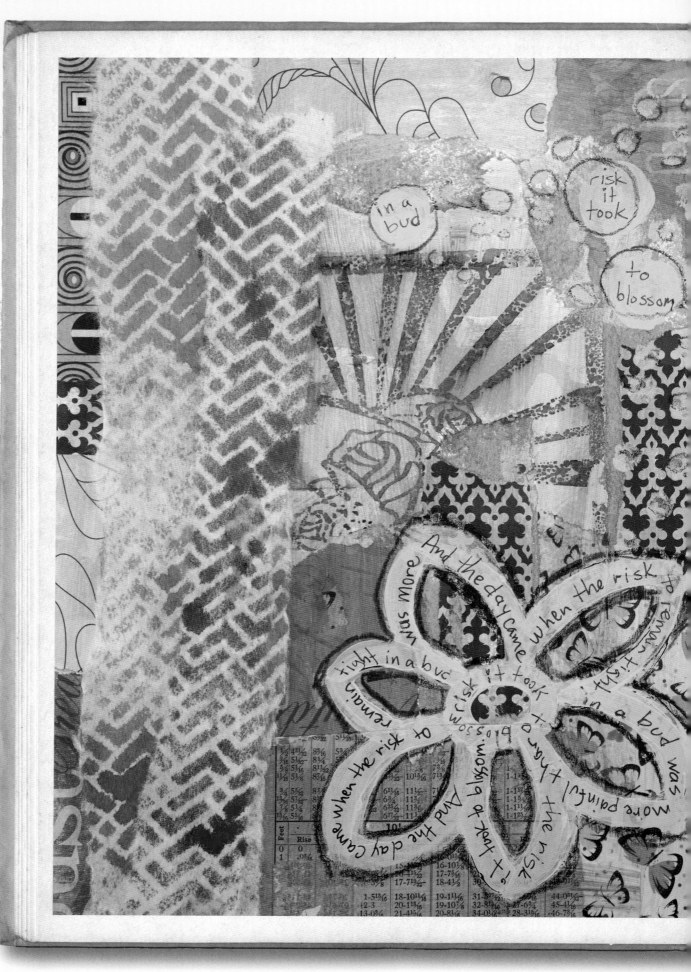

ART JOURNAL YOUR ARCHETYPES

Now that you've discovered your core guiding archetypes and learned some basics about supplies, you can begin exploring. What message does each archetype have for you? What clarification can you glean from your current career and relationships? How can you be more authentic with your archetypes as your guides? If you're in business, how can you market yourself to reflect your true energies? Which archetype was the biggest surprise? Was there an archetype you thought would be a core, but wasn't? How can each one of your archetypes help you take the next steps?

You can explore all of these questions and celebrate your archetypes by creating art journal pages. For me, writing is good but art-making is better. There's such a variety of techniques in this chapter, because I get bored doing the same kind of pages. The most important thing to keep in mind as you try out these techniques and ideas is that there is no right or wrong way to do them. Just have fun!

demonstration
ALTERED MAGAZINE IMAGES

This demonstration will show you a cool way to use magazine cutout images in your art journal pages. After reading this book, you'll never look at a magazine the same way again! If you are not comfortable drawing faces or people, then you'll love this technique. (Tamara Laporte used this method on her Queen journal page in Part 1.)

Follow the steps to learn how to use a magazine image as a base, while altering it to make it your own.

MATERIALS

SURFACE
- art paper or art journal

PAINTS
- acrylics
- Derwent Inktense Blocks

BRUSHES
- medium flat

STENCILS
- Mix Tape by The Crafter's Workshop

OTHER
- brayer
- ColorBox stylus and ink
- gesso (clear and white)
- glue
- magazine cutouts
- scissors

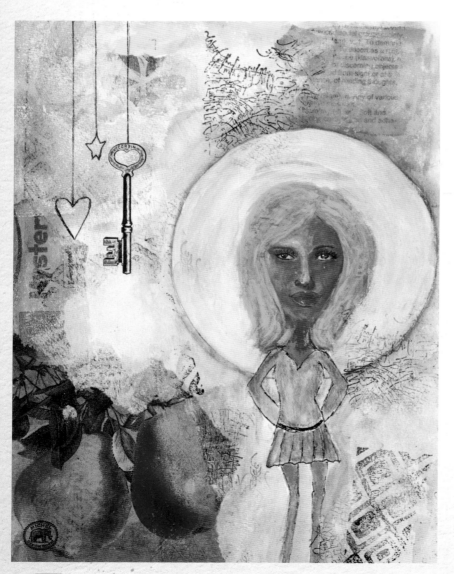

THE SEEKER
Gabrielle Javier-Cerulli
Mixed-media art journal page
with an altered magazine image.

She is looking for the key to her happiness. She knows it's in reach and by keeping true to herself, she will be grasp it soon…

Book print was used in the background at the top right—it always works well for layers and backgrounds. The pears at the bottom left are from a cocktail napkin.

The stamp at the top of the page is Creative Soul by Traci Bautista, and the one at the bottom right is by Stamp Francisco.

The key is a scratch-on image. The hanging heart and star come from Artistcellar's Hearts and Stars stencil by Tamara Laporte and were drawn with a Sharpie.

1 ADHERE AND GESSO OVER THE IMAGE

Complete a background on a page or use a page that you wish to cover up. (The background on this page includes washi tape, torn magazine pages, ink sprays and scrapbooking paper.)

Cut out an image of a person from a magazine. Glue it down and let dry. Cover it with clear gesso. This will add tooth to the page so that it is bumpy like a canvas. The color will stick better and it also gives subtle texture, but since you're using clear gesso, whatever is under it will show through. Let the gesso dry completely before moving on to the next step.

2 ALTER THE IMAGE

Begin altering the magazine image. You can add bangs, make the hair longer, apply different skin tones and add lipstick—all with Derwent Inktense Blocks, acrylic paint and white gesso. Use a wet medium flat brush to go over the areas where you applied the Inktense Blocks to blend the colors.

Note that I kept the eyes untouched on this one because I liked their color and intensity, but it's purely an artistic choice. You can make them blue, red or even rainbow if you want.

3 ADJUST THE BACKGROUND

Apply white gesso over the background (not the face) with a brayer. Let it dry. It may take 30–40 minutes.

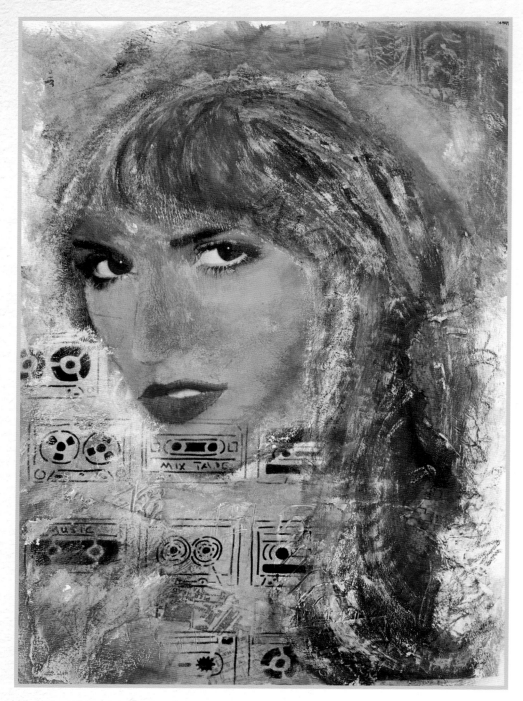

4 **FINISH THE BACKGROUND AND ADD FINAL TOUCHES**

Apply a light color of paint to the background. This will hush the background a bit so the face is more prominent. Add some wavy doodles with Inktense Blocks along with any other final details you like. (To finish, I applied black paint over The Crafter's Workshop's Mix Tape stencil by tapping a ColorBox stylus on the stencil.)

　　She's rock-and-roll. She's an independent thinker. She's The Rebel.

THE REBEL
Gabrielle Javier-Cerulli
Mixed-media art journal page with altered magazine image.

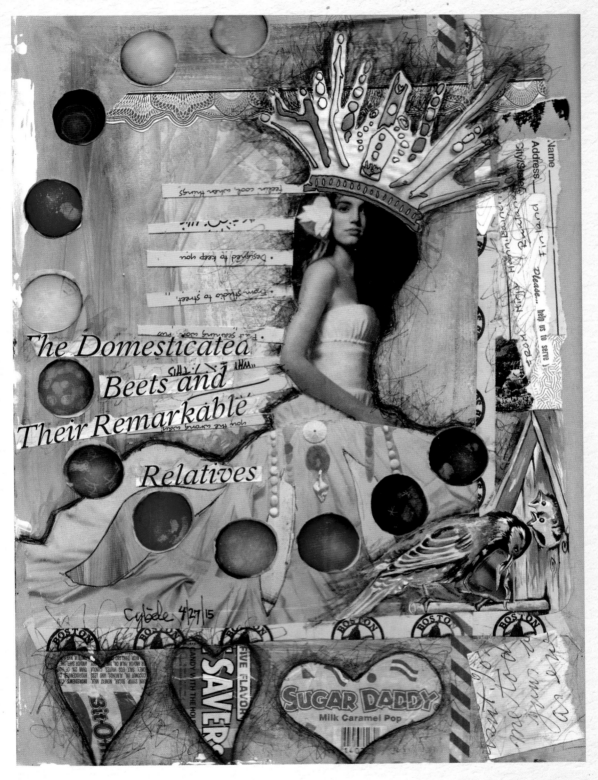

The Domesticated Beets and Their Remarkable Relatives

Cybele-Angelique Flematti is an artist from New Hampshire. This art journal page honors her Mother, Artist, Princess and Nature Gal archetypes. She altered the magazine image by adding embellishments to the woman's head and dress.

ALTERNATE ALTERATIONS
Cybele-Angelique Flematti
Mixed-media art journal page with altered magazine image.

demonstration

LAYERING STENCILS

There are many different techniques you can do with stencils. Layering stencils is a relatively easy way to get some interesting effects for your art journal pages. Here is a quick set of steps you can follow for layering stencils.

MATERIALS

SURFACE
- art paper or art journal

MARKERS
- black Sharpie

STENCILS
- Face Map Front Version 2 by StencilGirl
- Doodle It Geometric Landscape by StencilGirl

OTHER
- ink spray
- paper towels

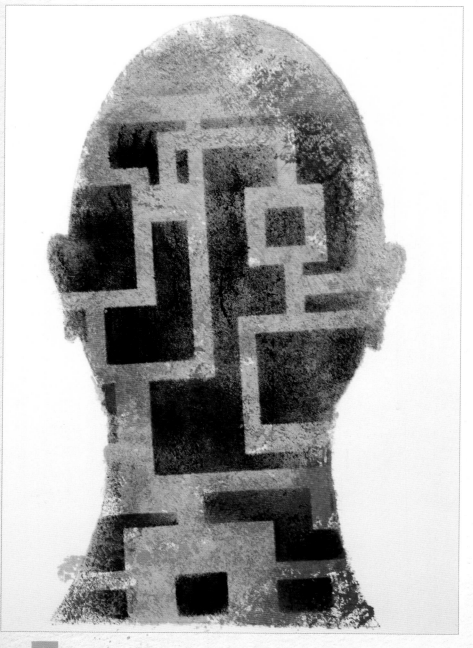

FACE MAP
Gabrielle Javier-Cerulli
Mixed-media art journal page
with layered stencils.

1 PREPARE THE BACKGROUND AND LAYER YOUR STENCILS

After you have prepared a background on a page, grab your first stencil and use a black Sharpie to outline it. (I used Face Map Front Verson 2.) Keep the first stencil in place and layer another stencil over it. (I used Doodle It Geometric Landscape.) Apply ink spray over the second stencil.

The first stencil acted as a mask to keep the ink spray inside the head shape. The second stencil created the design inside the head.

2 PEEL AND MOP

Carefully remove the stencils. Since you're using ink sprays, you'll need to mop up some of the extra ink. Roll a paper towel roll over the top or dab it with a single paper towel.

Then, flip the inked stencils and press them onto a different piece of paper or journal page. This will not only help clean your stencil, it could also be the beginning of a background for another journal page! When finished, wipe down your stencils with water.

SUGGESTIONS FOR ADDING DETAILS

- Go over the outline with Montana markers to thicken it.

- Add accents with India ink.

- Add some fine detail marks using a calligraphy pen.

- Place dots on the page with a Pearl Pen and then use a pin to draw the dots out into comma shapes.

TWO COLOR CHALLENGE

Nathalie Kalbach was moved to create her Judge art journal page (see Part 1) with just black and white paint. It's a great example of how much can be accomplished using only two colors. My artwork tends to be an explosion of color and texture, so I forced myself to make a journal page with just two colors. It was definitely a challenge! I had to do it twice. You'll see my first attempt on the next page and read about why it didn't work out.

Although it seems to lend itself naturally to The Judge, this technique could be used for any of the archetypes. I invite you to try the two color challenge. Will you welcome the simplicity of two colors, or will it feel too limiting?

MATERIALS

SURFACE
- art paper or art journal

PAINTS
- two colors of acrylics

BRUSHES
- two flats

OTHER
- Clear Tar Gel or String Gel
- color wheel
- palette knife
- sponge corner roller
- stencils of your choosing

GODDESS JOURNAL PAGE
Gabrielle Javier-Cerulli
Mixed-media art journal page with acrylic and Clear Tar Gel.

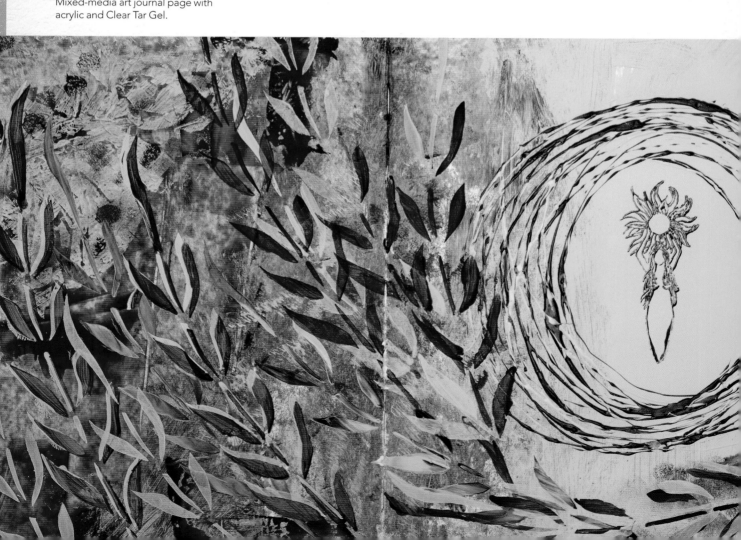

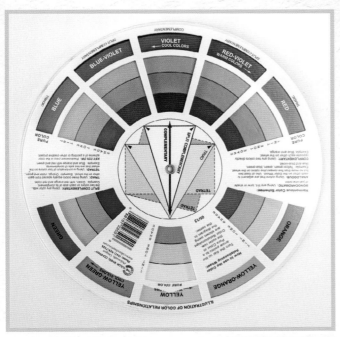

1 CHOOSE A COLOR SCHEME

Consult the color wheel to choose your color scheme. I chose to use purple and yellow because they are complementary colors, which means they are opposites on the color wheel. Red and green are also complementary colors, as are orange and blue. Complementary colors are high contrast, hence they are vibrant when used together.

2 APPLY YOUR COLORS

Use a flat brush to apply one of your acrylic paint colors to the left side of the paper. Then use a different flat brush to apply the second color to the other side. In the middle of the paper, blend the two colors with a sponge corner roller. (These can be found in hardware stores.) Continue building up layers of color on both sides of your composition. You want them pretty thick.

When mixing complementary colors, the more you mix, the muddier it will get. If you don't care for that look, let each layer dry first and then go over the top of it with the next color. This will result in a look that is less brownish.

3 ADD A STRINGY EFFECT

Mix acrylic paint with Clear Tar Gel by Golden or String Gel by Liquitex. Fold the paint into the gel instead of whipping it. It will pour much better this way. Dip a palette knife into the paint-and-gel mixture, then drizzle it onto your paper. (You could also use a plastic knife or a popsicle stick for this.) Let it dry and harden, which may take up to an hour.

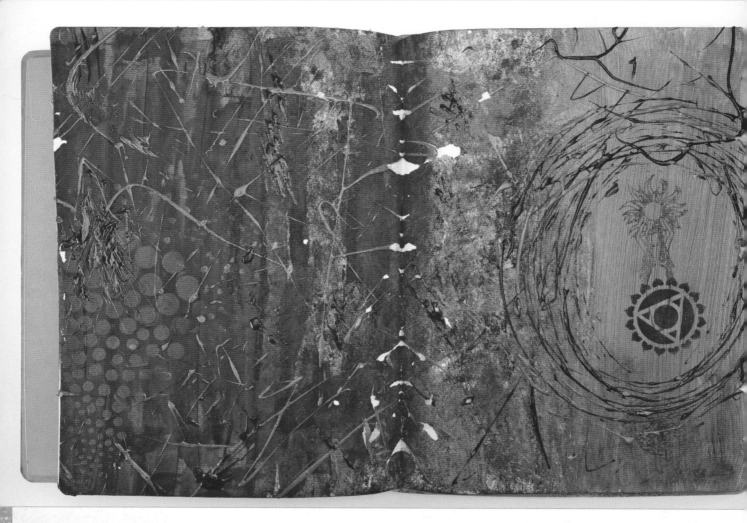

MY FIRST ATTEMPT

In my first attempt at the two color challenge, I used orange and red. If you refer back to the color wheel, you will see that these colors are next to each other. Instead of being complementary, they are analogous, so there is very little contrast. Rather than helping each other stand out, they sort of blur together, which is a good thing if you want a certain kind of harmony and cohesive look for your page. But if you're going for a high-contrast effect and want to make your page really pop, then it's best to stick with a complementary color scheme.

ANALOGOUS COLORS

Gabrielle Javier-Cerulli
Mixed-media art journal page with acrylic paint, Clear Tar Gel and stenciling.

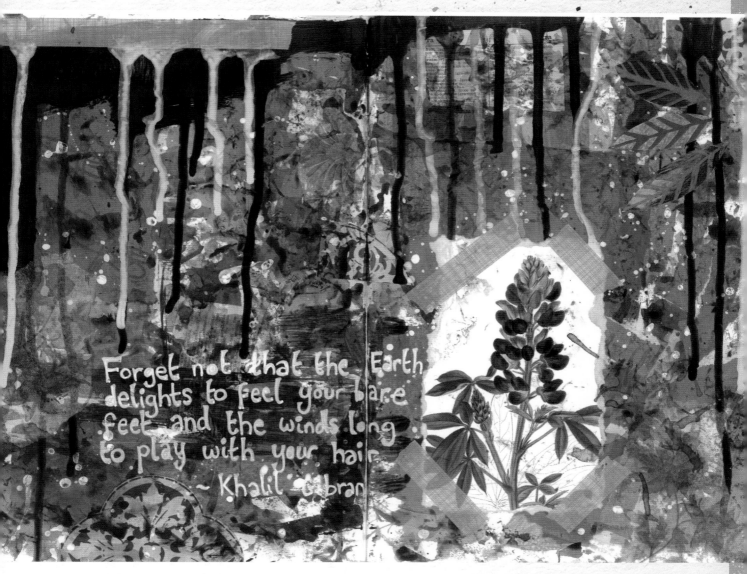

Forget not that the Earth delights to feel your bare feet and the winds long to play with your hair
~ Khalil Gibran

SUCCESS WITH ANALOGOUS COLORS

Catherine Mason is an artist and ecologist from Dorset, England. Her Nature Gal art journal page is mostly blue and green, which are analogous. But it works because that's the harmony she was going for. She used white paint as an accent color to add some "pop." The black is minimal.

THE NATURE GAL
Catherine Mason
Mixed-media art journal page with acrylic paint and stenciling.

LEARN MORE!

Visit velvetbarnacle.blogspot.com to learn more about Catherine Mason.

ALTERED POSTCARDS

Are you a Postcrosser? Never heard of it? I'm a fan as well as a member. You send and receive postcards from all over the world.

It all started when I wanted to introduce geography to my son, who was a toddler at the time. So we signed up on postcrossing.com and started receiving postcards. Whenever a new postcard came, we looked at a map to connect it to the country from where it had traveled. I vividly remember my son running to the map with a postcard smiling and yelling, ''It's from Belarus! Belarus!''

Now we have a hefty postcard collection. There are a few dozen postcards that will never see the end of a pair of scissors, but there are several others (and some gorgeous stamps too!) that I've cut up to use for art journaling, canvases and mail art.

If you've ever had a journal page that's gotten completely out of control, this is a great technique for when you need to cover up and start from scratch. The first layer will help with the texture of the finished page. You can even write out your feelings or a story, then cover it up so only you will be privy to the secret background story.

MATERIALS

SURFACE
- art paper or art journal

PAINTS
- high-flow acrylics
- Tim Holtz Distress Paints or craft paint

BRUSHES
- large flat

STENCILS
- Cursive Alphabet by The Crafter's Workshop
- Splatter by Tim Holtz
- Diagonal and Dots by Artistcellar

OTHER
- black gesso
- fine-grit sandpaper
- Golden Acrylic Glaze
- mini spatula
- Mod Podge
- old credit card
- postcard
- rubber band or string
- wax paper
- white gesso
- white transfer paper

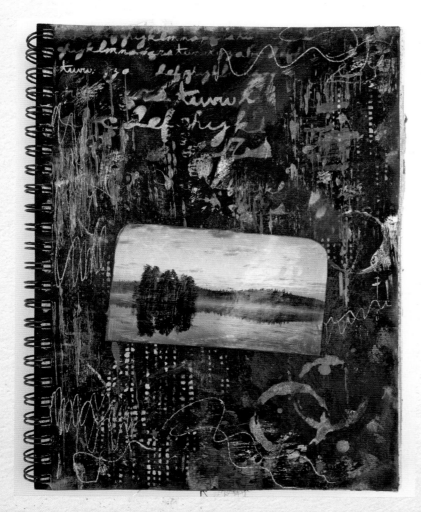

THE MYSTIC/NATURE GIRL
Gabrielle Javier-Cerulli
Mixed-media art journal page with an altered postcard.

She believes she's connected to everything on this planet and beyond. She must be outdoors to feel grounded. She picks up on and strives to give off positive vibrations.

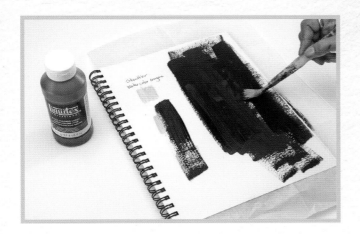

1 COAT THE PAGE WITH BLACK GESSO

Place a sheet of wax paper between your journal pages in order to protect them and your work surface. Use a large flat brush to apply black gesso over the page in an even coat. For a distressed look, leave some of the white page or whatever was underneath peeking through the black gesso in random spots. If you're using spiral-bound pages, be sure to get in between the spirals with a thin brush to cover the whole page for a cohesive look and feel.

2 SAND DOWN THE IMAGE

Use fine-grit sandpaper to sand down the front of the postcard to give it a distressed look and take the gloss off it. If you're using a black gesso background, it's a good idea to use an image with a lot of light in it, such as a seascape.

3 SEPARATE THE IMAGE FROM THE BACKING (OPTIONAL)

It gets a little tricky here, so take your time. In order to have a malleable image, you'll need to separate the front picture layer of the postcard from its backing. Starting at the corner of the postcard, use your fingernails to separate and slowly peel off the front of the postcard. You can use the backing, where the note from the sender is, for this project as well, or save it for another project later.

If you prefer to work with a rigid postcard, you can skip this step.

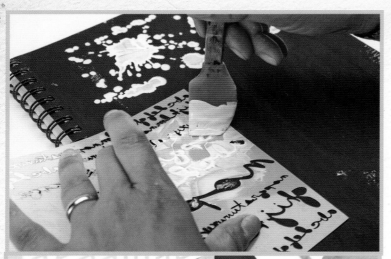

4 APPLY THE STENCIL LAYER

Lay stencils on the journal page and go over them with white gesso using a mini spatula. Then switch to a brush and stipple for a finished effect. Let it dry.

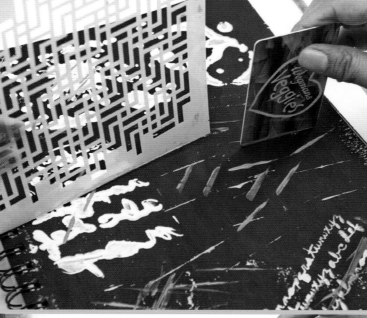

5 ADD TEXTURE AND DETAILS

Dip the edge of the stencil in some paint and apply random straight marks on the page. Do the same with an old credit card.

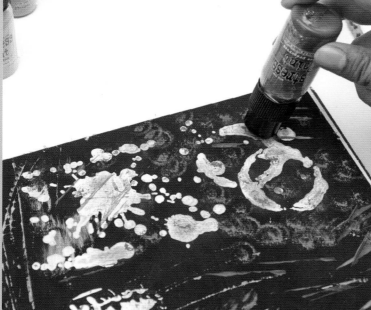

6 ADD SOME COLOR

Apply color randomly and over some of the white areas with Tim Holtz Distress Paints or craft paint.

7 FLOG IT

Time to flog your page! (What?) Cut a rubber band or some string, dip it in fluid paint such as high-flow acrylic or craft paint, then start "flogging" and "whipping" the page with it. This will create splatters and varied lines. You can also twist the rubber band on the page for even more funky random marks.

8 FIX THE "DEAD" AREAS

Step away from your page for several minutes, hours or days. When you return, review each section. Are there any areas that are missing something? Maybe it's missing color, or texture, or pattern. Or maybe one area doesn't vibrate and flow like the rest of your page.

One way to tackle a dead area is to add some squiggles using white transfer paper and the back of a paintbrush. This creates a kind of chalky effect. You can also use a white Sharpie, white paint or white China marker for different effects. If you use actual chalk, be sure to spray with a fixative so it doesn't erase off.

Or maybe there's an area that has too much going on and is distracting. This can happen when a section is overcrowded with color or texture. In that case, you can mute it by covering lightly with white gesso, white paint or a glaze.

WHITE AS A CREATIVE CHOICE

The creative use of white space does not a dead area make! White space can create a feeling of calm, flow and openness. A dead area doesn't elicit any feeling—it's just *blah.* Remember that Titanium White is opaque and Zinc White (also called Mixing White) is transparent. So the "right" white depends on what your goal is for the journal page.

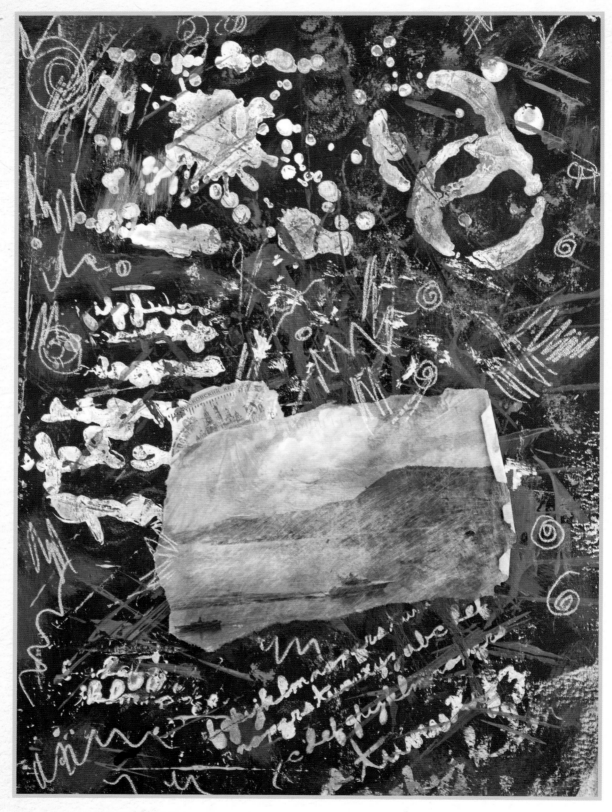

9 **FINISH WITH DETAILS**
Add final touches and embellishments to finish.

THE MYSTIC/NATURE GIRL
Gabrielle Javier-Cerulli
Mixed-media art journal page with altered postcard.

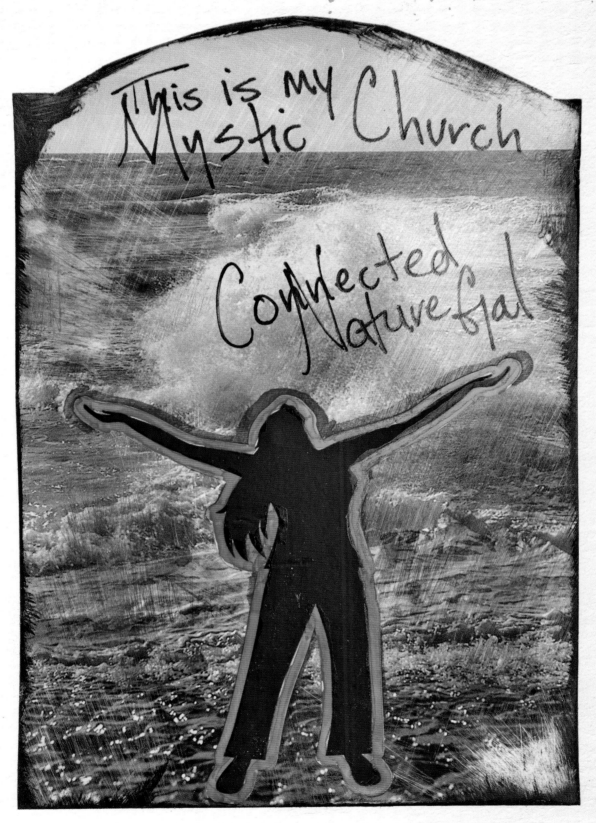

This was a quick altered postcard for a friend who has a deep connection with the ocean. Blue paint was added to the ocean, and the sticker of the woman is available on my website (gabriellejaviercerulli.com).

THE MYSTIC/NATURE GIRL
Gabrielle Javier-Cerulli
Mixed-media art journal page with altered postcard and Open Arms sticker.

RIPPED COLLAGE LAYERS AND SLIDE GLASS

Most art journalers and mixed-media artists always have an eye out for new, unique or overlooked art supplies. We often end up finding these treasures at home improvement stores, yard sales or even deep in the forgotten crevices of our studios. That's what happened with these small glass slides. I was in the throes of a de-stashing (de-stash = donate, sell or trade your unused materials) when I found this little box of microscope glass that I had bought ages ago, intending to make some sort of jewelry with them. Initially I thought they were too dangerous to include in my art journals because they would break. Then my Rebel archetype took over and said, "So what? Let's try it! What's a little broken glass for art's sake?" So I tried it and not only did I really dig it, but my art journals have been tossed all over—shipped, flown, manhandled—and not one piece of broken glass!

MATERIALS

SURFACE
- art paper or art journal

PAINTS
- acrylics
- watercolors

BRUSHES
- large flat

OTHER
- eyes image cut from a magazine
- face/head image cut from a magazine
- gaffer tape, duct tape or masking tape
- Golden Gel Medium or Mod Podge
- ink spray
- microscope slide glass
- pencil
- scissors
- scraps of paper for collage

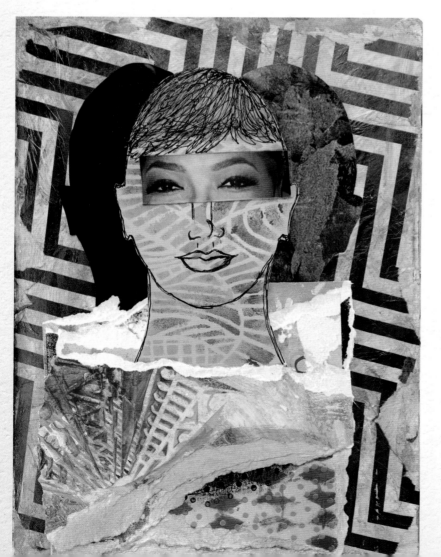

THE VISIONARY/SEEKER
Gabrielle Javier-Cerulli
Mixed-media art journal page with slide glass and ripped collage papers. Face Map Front Version 2 and Zen Landscape stencils by StencilGirl.

She has plenty of ideas and is working towards a path that is in alignment with her energies and principles. She is on the way to being a catalyst for bettering her community.

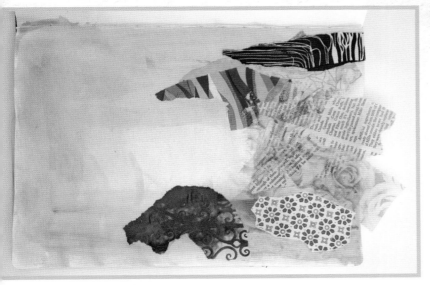

1 APPLY A COLOR WASH AND LAYER COLLAGE PAPERS

Apply a wash of color to the journal page. Rip pieces of papers (magazine, scrapbooking, newspaper, etc.). Glue them onto the page and on top of one another with Golden Gel Medium or Mod Podge. When all of your pieces are glued down, wait about 10 minutes to let it dry— but not completely.

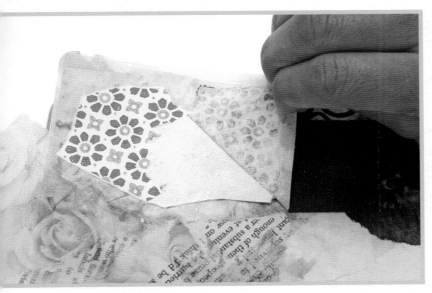

2 PEEL BACK SOME OF THE COLLAGE LAYERS

The key to peeling is to do it before the glue dries completely between the layers. Place gaffer tape, duct tape or masking tape over the portion of the collage paper that you want to peel away. (If you do not have any of these kinds of tape, you can try to peel with your fingernails.) Whatever is attached to the tape will come up with it, exposing the layers underneath. The randomness of the tearing adds to the excitement and texture of the page.

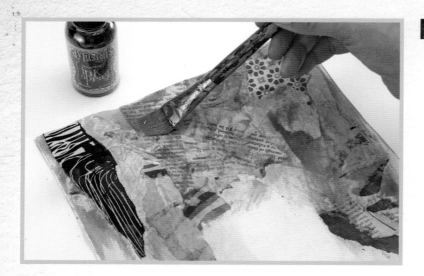

3 APPLY INK SPRAY

Apply an ink spray to make the background uniform. (I used Dylusions Dirty Martini green.) Spray a bit of ink over the collaged page, then spray with water to de-saturate the color a bit. Using a large flat brush, paint over the entire sheet of paper. If you prefer, you can also use watered-down acrylic for this.

4 MAKE GLASS EYES

Grab a magazine. Set the glass on top of an image of eyes or one big eye. Use a pencil to mark off the rectangle. Then cut out the eyes and glue them to the back of a glass slide.

WARNING!

Be careful while handling these slides. They are glass and, therefore, breakable. The edges are also more sharp than you might imagine. Not as sharp as a razor blade, but sharp enough that you still need to be careful. You can wear gardening gloves if you want to be really cautious.

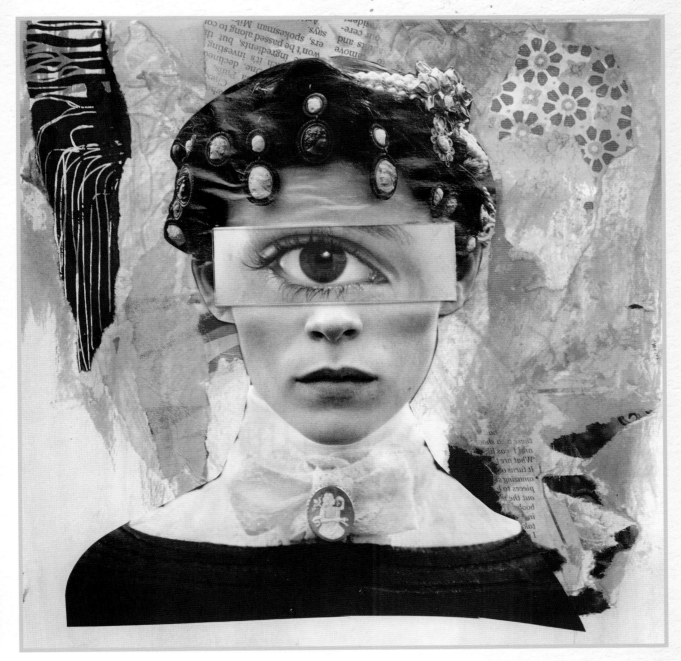

5 PLACE THE FACE AND SLIDE AND FINISH WITH DETAILS

Cut out an image of a face or head from a magazine and use Golden Gel Medium or Mod Podge to adhere it to your page. Then adhere the slide glass eyes on top of the face image.

Play around with details and add whatever embellishments and finishing touches you like. (I almost cut this image at the neck, but the neckline and fabric were just too perfect!)

THE MYSTIC/HERMIT/JUDGE
Gabrielle Javier-Cerulli
Mixed-media art journal page with collage and slide glass.

With her intense central eye, she sees things most others either cannot or choose not to see—both now and in the future. She will critique your life choices, sometimes harshly. She prefers to be alone because being with other human beings drains her potent connection with the Other.

GELLI PLATE PRINTING

I'm really curious to know how many readers of this book already own the incredible Gelli Arts Gel Printing Plate. I have a feeling a lot of you folks know about it. If you fall into that category, this demonstration will show you a great way to use up some of your Gelli prints. And if you're not familiar with the Gelli plate, hold on to your hat because things are about to get crazy!

A word of warning—this is highly addictive! Once you get going, you'll wonder what to do with all your piles of finished prints. I must confess, I once went on a Gelli plate "bender" and printed close to 100 sheets in one sitting. It kind of felt like a meditation.

Check out gelliearts.com for more ideas and cleaning and storage instructions.

MATERIALS

SURFACE
- copy paper or watercolor paper
- deli paper

PAINTS
- acrylics or craft paint

OTHER
- brayer
- Gelli Arts Gel Printing Plate
- scissors
- texturizing tools of your choice

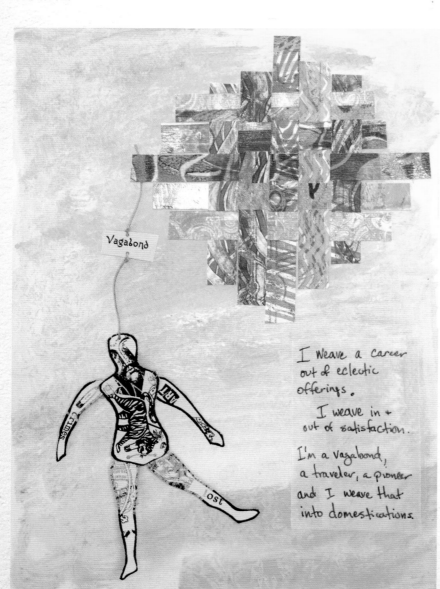

I weave a career out of eclectic offerings.

I weave in & out of satisfaction.

I'm a Vagabond, a traveler, a pioneer and I weave that into domestications.

VAGABOND
Gabrielle Javier-Cerulli
Mixed-media art journal page with Gelli printing.

The woven embellishment at the top right of the page was created by cutting identical-sized strips of Gelli prints and then weaving them together. I cut a variety of lengths for interest. The Vagabond's body is a Personal Passion Puppet created by Martha Schermerhorn and is available for purchase at mostlyartistsbooks.com.

WITH COPY PAPER

1 APPLY THE PAINT

Squeeze dots of three different colors of paint onto the middle of the Gelli plate. (I used orange, green and yellow craft paint.) Spread the paint horizontally with a brayer.

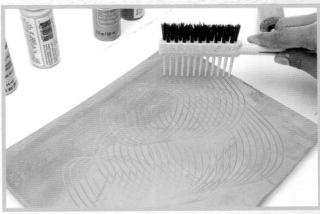

2 ADD TEXTURE

Use a tool to create some texture. (I used a house painter's comb.) You can use stamps, palette knives, sponges or any other texturizing tool—the list is endless.

3 APPLY THE PAPER

Place a sheet of paper over the top of the plate and rub the back of the paper. (I used copy paper here, although I usually use either watercolor paper for a thicker weight or deli paper for a thin flexible weight.) There are so many different types of paper and materials you can use. Have fun experimenting!

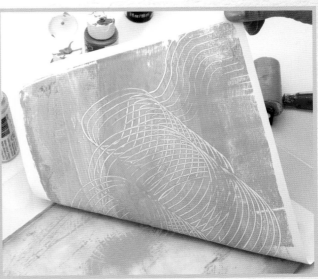

4 PEEL AWAY THE PAPER

Slowly peel back the paper to reveal the print. After you take off the sheet, you may be able to apply another piece of paper to get a faded second print. Once you make a print, you can use that same print to layer on another print with different colors, images and textures. Most of the time, prints come out the way you expect them to. But there are other times when the paint may not stick properly to the whole paper, or the paint gets smudged. Those are the happy accidents.

WITH DELI PAPER

Deli paper is different from wax paper. Regular wax paper resists paint, while deli paper accepts it. You can make a bunch of prints on deli paper sheets and cut, rip and stamp on them to incorporate into your art journal.

Or you could use deli paper as a mask, which means you can block out the paint from a certain area. See the following example.

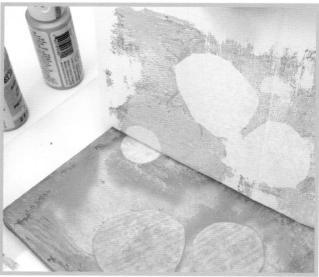

1 CUT AND PLACE DELI PAPER CIRCLES

Apply the paint colors of your choosing to the Gelli plate. Cut out deli paper circles and place them on the Gelli plate.

2 APPLY PAINT AND PRINT

Apply paint over the deli paper circles. You can see white circles on the print where the deli paper blocked the paint from getting on the sheet. These circles could be filled in with writing, drawing or stamping. As for the circles on the plate, they can be kept for future use as embellishments for another art journal page.

A LITTLE GELLI HISTORY

Before the Gelli Arts Gel Printing Plate arrived on the art-making scene, if you wanted to make gelatin prints you had to buy powdered gelatin at the grocery store, mix it with hot water, pour it into a jelly roll pan, place it in the refrigerator and wait a whole day for it to form. Then you could finally get to work—paint, tools, brayer, paper—over and over.

But after so many prints and hours of use, the semi-solid gelatin form would begin to split or crumble. So you'd have to start the whole process over from scratch again. As I threw the crumbles into the garbage can, I used to ponder, *Why hasn't someone come up with a reusable gelatin thingy?* Then someone did!

Joan Bess and Lou Ann Gleason partnered up, and the rest is history. Joan has many videos showing different ways to use and clean the Gelli plate. They now come in a variety of sizes and shapes, too! I love that it is not only reusable, but easy to clean and store. I've had mine for years now and it's still in great shape.

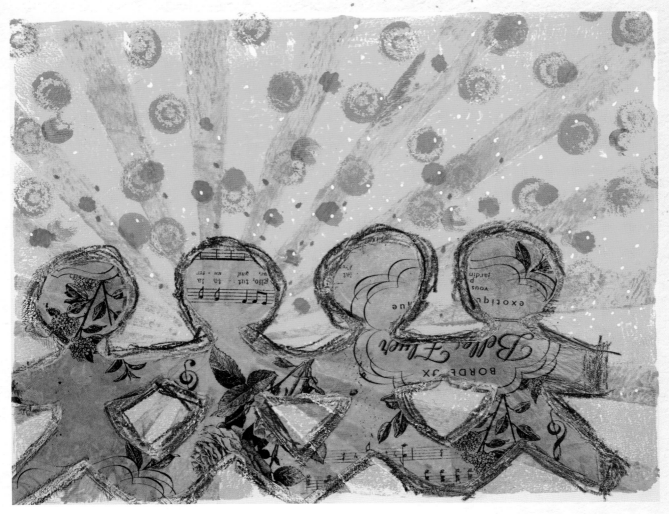

The Networker is a connector and believes in the value of collaboration over competition. She naturally links people to each other so they can build a professional or personal relationship.

This page was created by using the Gelli plate and the Circle Ray stencil by StencilGirl. I used Tim Holtz Distress Paints with the dabber for the polka dots. I cut the people out of tissue paper and used a China marker to outline them.

THE NETWORKER
Gabrielle Javier-Cerulli
Mixed-media art journal page with Gelli printing.

SEE IT IN ACTION!

I made this Networker journal page for the TEDx Flour City talk I gave in May 2015. You can view this page and watch the TEDx talk at youtube.com/watch?v=xyOYM4XHVXI.

HEARTS TWO WAYS

Hearts symbolize love, affection, fondness, friendship, parenthood, sisterhood and self-acceptance. These hearts can be used for The Lover or The Mother, or you can add these elements to any archetype page that really moves you.

The first heart we will make is a collage technique using strips of scrapbooking paper. But you can cut strips from magazines, music sheets, old school workbooks, pretty much anything. This kind of collaging can be applied to a variety of shapes, such as a star, a horse, a circle or a downtown skyline, then incorporated into a journal page. The second heart we'll cover is a three-dimensional pop-up, also made with paper.

Art journal pages with hearts can be created as a pep-talk reminder for yourself. Or you can make one to give as a gift. No matter who receives it, the message is the same.

MATERIALS

- cardstock
- glue
- scrapbook paper
- scissors or paper cutter

THE LOVER
Gabrielle Javier-Cerulli
Mixed-media art journal page with collage.

The Lover has a big heart, is very empathetic and believes all of life boils down to love.

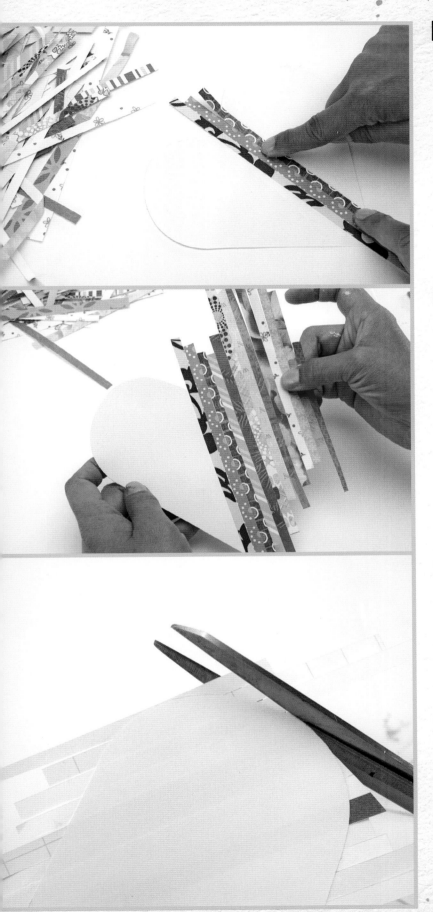

1 ## CUT OUT THE HEART SHAPE

Cut out a heart shape from cardstock paper or use a die-cut heart. Then cut out strips from a variety of scrapbook paper or magazines. Make sure they are close to the same width. If ryou use a paper cutter for this it will be much easier than with scissors. (I prefer my personal paper cutter with a rotary blade to the guillotine-style paper cutter with the big blade and handle.)

2 ## GLUE THE SCRAPBOOK STRIPS ONTO THE HEART

Glue down the strips of scrapbook paper onto the heart. It's easiest to start from the center and work your way to the edges. (I like to apply glue to the heart, then line up the strips and press down.) Make sure not to place any strips with matching patterns next to each other.

3 ## TRIM THE EDGES

When all strips are down and the glue is dry, flip the heart over. Cut off the extra bits from the strips following along the heart shape. You could avoid this step if you measure out the strips beforehand, but this takes a lot of time.

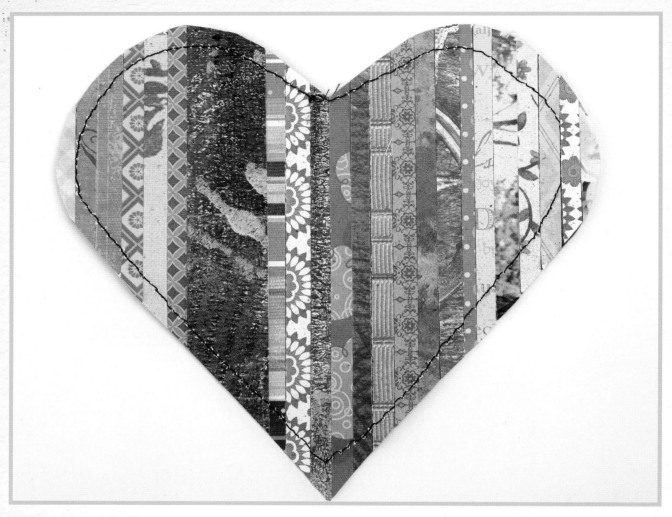

4 ADD FINISHING TOUCHES

Add whatever details and embellishments you like to finish your heart. This one has a simple stitch-around that was done on a sewing machine.

FOLDED HEARTS

For this dimensional pop-up heart, cut three hearts the exact same size. You can use the same patterned paper for them or use three different patterns. Hold heart #1; this is your center. Glue one section of heart #2 to the left back of heart #1. Next, glue one section of heart #3 to the right back of heart #1. Then glue the back down so the front pops up.

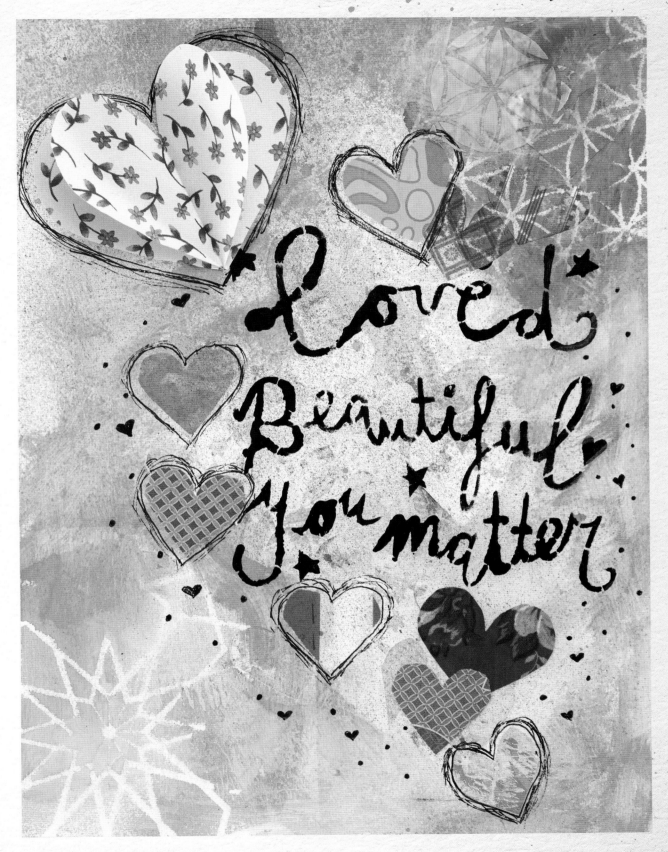

LOVED, BEAUTIFUL, YOU MATTER
Gabrielle Javier-Cerulli
Mixed-media art journal page with folded-heart collage, ink sprays
and stenciled lettering using the Love stencil by Tamara Laporte.

WASHI TAPE BIRDS

These little guys work great for making journal pages for the Nature Gal/Guy, Mother/Father, Artist and even Comedian archetypes. Although we will be creating bird cutouts here, this technique can be applied to any shape, such as a tree, a crab, a horse, a unicorn or a bridge.

MATERIALS

SURFACE
- cardstock or watercolor paper

STENCILS
- Tall Birds by StencilGirl

OTHER
- pencil
- scissors
- washi tape

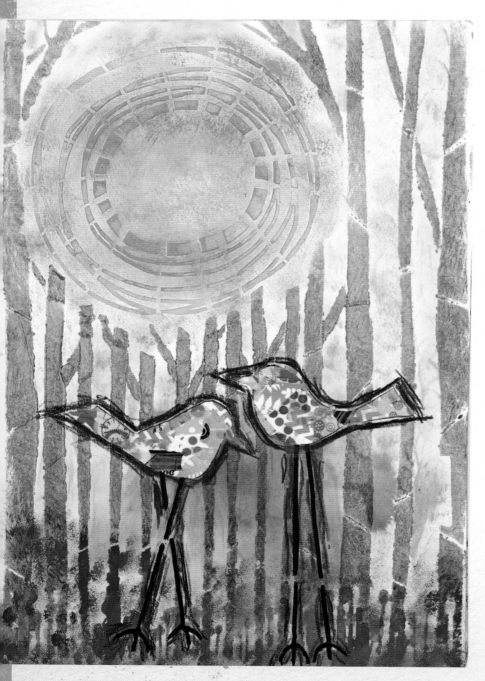

THE NATURE GAL/GUY
Gabrielle Javier-Cerulli
Mixed-media art journal page with washi tape.

This Nature Gal is at home in the woods and is a bird enthusiast. She needs to feel the sun on her skin and work in her garden. When she isn't in her element, she is sullen.

The page was created by first applying blue and purple ink spray. Then I used the Celestial Grove stencil by StencilGirl for the trees and sun. The sun's texture was created with molding paste. After gluing the washi tape birds, I added the legs using the Tall Birds stencil and a Sharpie. Lastly, I added details with a China marker.

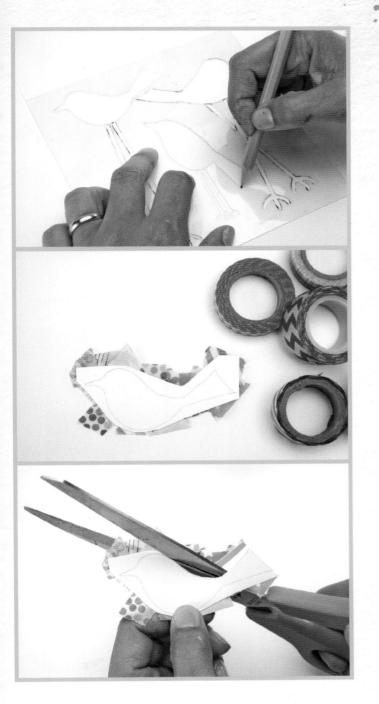

1 TRACE THE BIRDS

Using StencilGirl's Tall Birds stencil, trace out some birds onto white paper. Cardstock or watercolor paper will work best.

2 MAKE A ROUGH CUT AND APPLY THE WASHI TAPE

Roughly cut around the stenciled image. Apply various patterns of washi tape to the back. Have the tape hanging over the edges.

3 TRIM IT

Trim the bird to the pencil outline of your stencil. Then flip over to see your completed bird.

TRY IT WITH STAMPS

You can achieve a similar effect utilizing used postage stamps. They are colorful, and the black lines of the cancellation stamp will add interest.

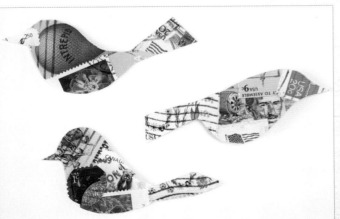

PAISLEY BIRDS

These cute paisley birds work great for journal pages involving the Nature Gal/Guy and Mother/Father archetypes. In this demonstration, we will explore two ways of creating paisley birds using two different materials: Inka Gold for a shiny, thick bird, and PanPastels for a bird with soft and muted colors.

MATERIALS

SURFACE
- art paper

PAINTS
- craft paint
- Inka Gold
- PanPastels

MARKERS
- China marker
- Sharpie or watercolor marker

STENCILS
- Jessica Sporn's Paisley Floral Repeat by StencilGirl

OTHER
- latex gloves
- Ranger Mini Ink Blending Tool
- scissors

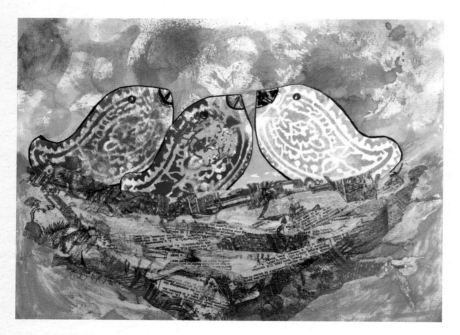

WHAT MY MOM SEES
Gabrielle Javier-Cerulli
Mixed-media art journal page with stencils and stamping.

This page was inspired by the bird on Jessica Sporn's journal page, The Bird Whisperer, *in Part 1. Something about the sweetness of that little blue bird prompted me to make a whole bunch one day not knowing what I'd do with them. When I laid them out these three were next to each other, and they looked like siblings. I was moved to place them in a safe home and used strips of different tissue paper to create the nest. Next came the green to indicate leaves, and then the sky background to add brightness to the page. At first I thought my Mother archetype was influencing this page. But I actually think it's me honoring my own mother and her Mother archetype. No matter what our age, she will always see us as her baby birds.*

WITH INKA GOLD

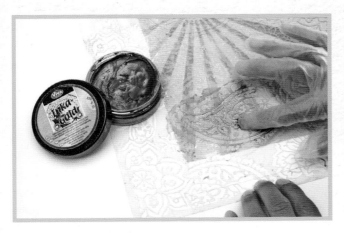

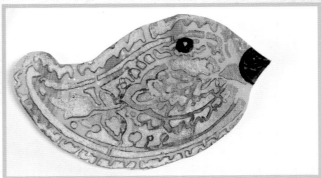

1 APPLY COLOR

Lay the stencil onto a page with a prepared background. (I used a Gelli plate print.) Put on latex gloves and apply Inka Gold over the stencil with your finger. It's thick and has a paste-like consistency.

2 PEEL AND TRIM

Slowly peel back the stencil. Once the Inka Gold has dried, cut out the bird shape. Color the beak and eye black with a China marker, watercolor marker, acrylic craft paint or a Sharpie.

WITH PANPASTELS

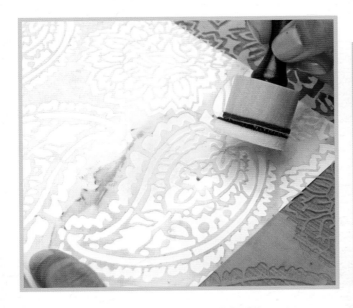

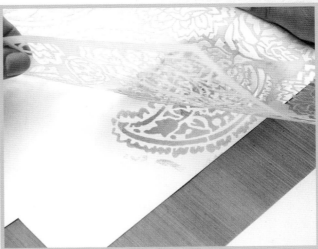

1 APPLY THE FIRST LAYER OF COLOR

Get out the PanPastels for another bird. Apply your first color with the Ranger Mini Ink Blending Tool. I recommend using a light color as your first color.

2 APPLY THE SECOND LAYER OF COLOR

Apply a second darker color by lightly dabbing and swirling over the first color. Before you cut it out, sketch a beak. Color the beak and eye black with a China marker, watercolor marker, acrylic craft paint or a Sharpie. If you like, you can outline the bird's edges with a black marker or ink pen.

THE WINGED ONES

Some of us fly at all times. Some of us fly on occasion. Some of us wish to fly. Wings symbolize flight, fleeing, independence, nature and the supernatural. Create these wings for people or for non-winged animals, fairies, butterflies and airplanes.

Angelina film is a cool product. It is formed as iridescent sheets that can be heat-bonded, stamped and stitched. It comes in many colors. Besides making wings, you can make a pillow or envelope with it by cutting two squares that are the same size, adding some treasure in the middle, such as words, beads, hair or spices, then fusing the sides together, avoiding the middle. You can also crinkle it by applying heat, then glue or stitch it in your art journal for shimmery pops of color.

MATERIALS

- Angelina film
- candle
- floral wire
- heat gun or hair dryer
- matches or lighter
- wire cutter

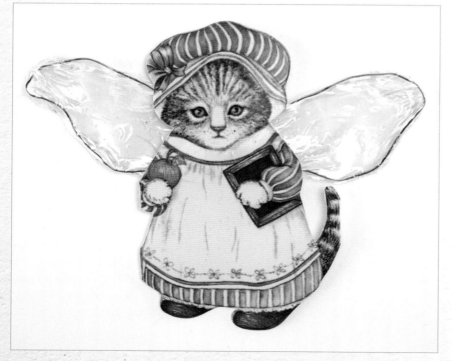

GUARDIAN TEACHER

This little gal, who represents The Teacher archetype for me, comes along while I'm facilitating a workshop. She is either in my bag or out for all to see. She's a reminder that teaching others is a way of liberating them. Her matronly attire makes me laugh.

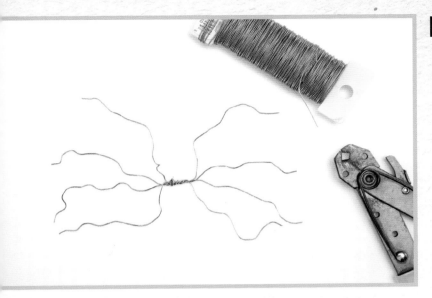

1 MEASURE AND CUT THE WIRE

Cut out four strips of wire with a wire cutter. They should all be the same size—about 5" (13cm). Then twist the wire together in the center to form a set of wings.

2 FOLD THE FILM OVER THE WINGS AND HEAT

Cut a 6" (15cm) piece of Angelina film. Fold it over one of the wire wings. If you have a heat gun, run it over the film for a few seconds to start fusing the film together. If you do no have a heat gun, a hair dryer will do. If that doesn't work, you can set your clothes iron to the lowest setting, cover the film with parchment paper, then gently run the iron over the parchment paper for a few seconds.

WARNING!

The next steps in this project involve the use of a lit candle, so please be very careful. You may want to consider doing this near a sink so that you have water and a basin readily available. If you are a minor, ask an adult to help or supervise.

3 FUSE THE FILM

Now you need to add more shape to it. While holding the bare wire wing, hover the wing with the film over a lit candle to fuse the film. If you hold it a little longer in some areas, it will melt the film. You do not want to be too close—keep it about 3–4 inches (8cm–10cm) above the flame. The film will form around the wire.

4 FLIP THE WING

Flip the wing over and heat the backside as well. Be careful not to let it get too hot, or it will burn. Turn the wing to the side to get a curved shape. Now repeat Steps 2-4 for the other wing.

Depending on how you shaped the wires in Step 1, you could create a forewing and a hind wing like a butterfly.

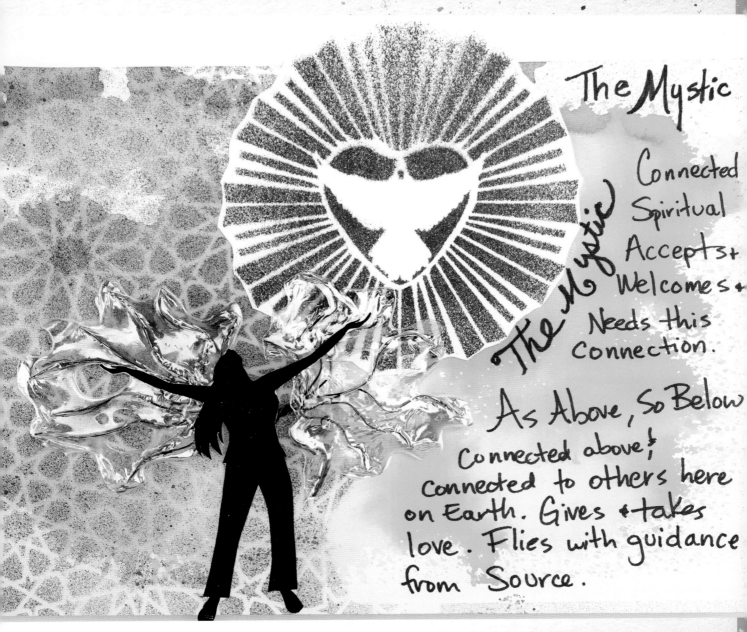

The Mystic

The Mystic

Connected
Spiritual
Accepts+
Welcomes+
Needs this
Connection.

As Above, So Below
Connected above+
Connected to others here
on Earth. Gives +takes
love. Flies with guidance
from Source.

She is open to give and receive. She is a vessel and her connection fills her. She's ready to fly and spread joy.

 This journal page was created with my Open Arms silhouette, which comes as a downloadable printout or as a sticker. Go to my website gabriellejaviercerulli.com to see both. The background was created with ink sprays and the Celestial stencil by Artistcellar. The dove in the heart was created with the Spirit stencil by Artistcellar.

THE MYSTIC
Gabrielle Javier-Cerulli
Mixed-media art journal page
with Angelina film, ink sprays and
stencils.

ORIGAMI DRESSES

Move over little black dress—there's a cuter one in town! Depending on the pattern of the paper and the rest of your journal page, these sweet origami dresses work great for the following archetypes: Princess, Mother, Networker and Teacher. And besides looking great in your art journal, these can also be used for invitations, place settings, Mother's Day cards or birthday cards.

Follow the steps to create an origami dress and then incorporate it into a journal page.

MATERIALS

SURFACE
- art paper or art journal

PAINTS
- Tim Holtz Distress Paints

MARKERS
- Copic
- Letraset
- Prismacolor

STENCILS
- Letter Jumble by Dylusions
- Unconnected Circles by StencilGirl

OTHER
- 6" x 6" (15cm x 15cm) square origami paper
- face or head magazine image
- Golden Gel Medium
- nail polish
- old credit card
- rice paper
- scissors

THE PRINCESS
Gabrielle Javier-Cerulli
Mixed-media art journal page
with origami.

The Princess is attractive, yet approachable. People like her. She always looks nice, like in a cute dress. Her life has been comfortable; she doesn't have to worry much. She isn't desperate or in need of saving. She's taken care of.

■ MAKE THE DRESS

1 **MAKE THE FIRST FOLD**
Fold a piece of origami paper in half as shown.

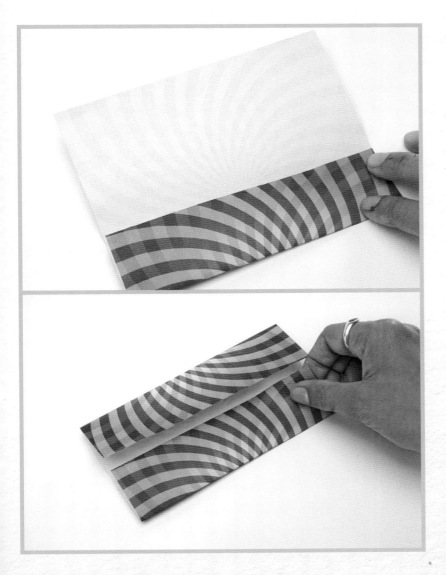

2 **FLIP AND FOLD**
Flip the paper over and fold each side to the center crease.

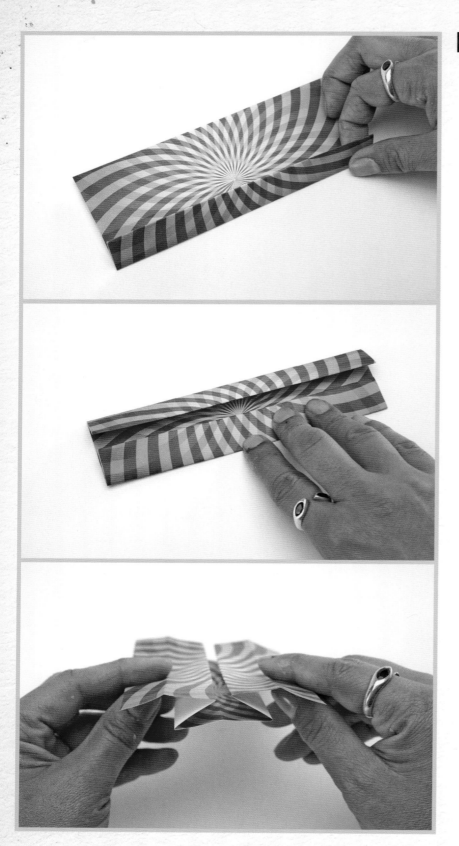

3 FLIP BACK AND FOLD AGAIN

Flip the paper back over to the other side and fold each side to the center again.

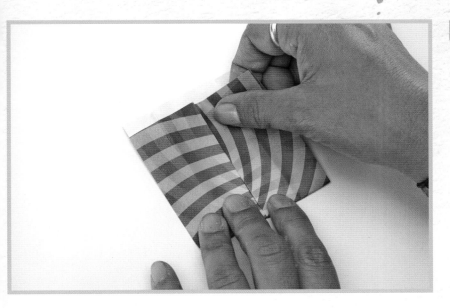

4 MAKE A VERTICAL FOLD

Fold it in half vertically.

5 FOLD THE WAISTLINE

Make a second crease about ⅛"
(30mm) above the first crease, bringing
the paper towards you. The paper
should be making a Z, which can be
seen from the side. Now you have a top
and bottom.

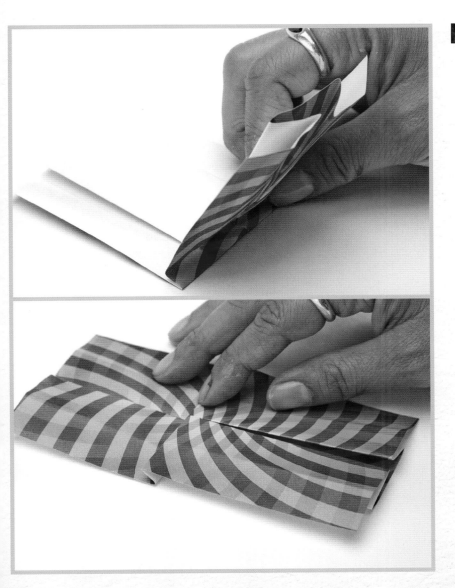

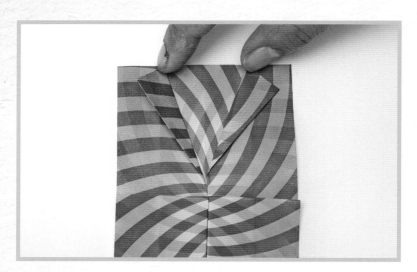

6 **START THE NECKLINE**

Grab the center edge on the top section and fold it over at 20°.

7 **MAKE PLEATS**

Grab the bottom right corner edge and pull right. Press down a crease in the middle and at the waistline. Repeat on the other side.

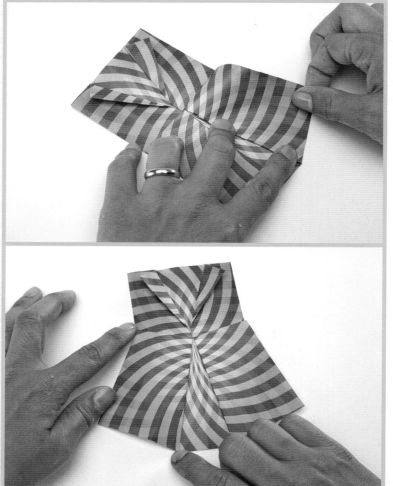

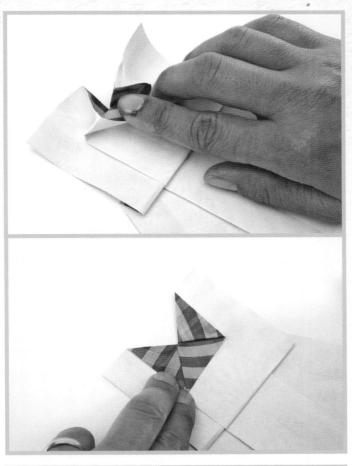

8 **FINISH THE NECKLINE**

Flip the paper over and press back in the center. The paper will "butterfly" out. Then press the sides down.

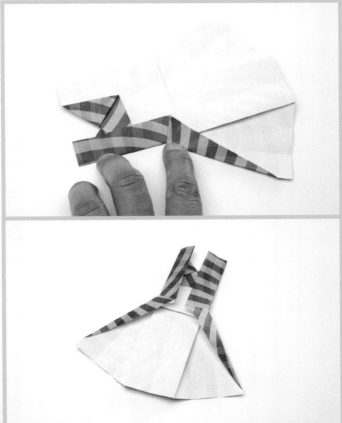

9 **DEFINE THE SHOULDERS AND WAISTLINE**

Fold in the paper where the shoulder would be. Then fold at an angle from the waist to the bottom of the dress. Repeat on the other side. This is what the back should look like.

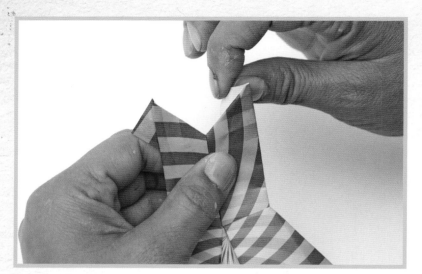

10 **MAKE THE SLEEVES**
Fold the cap sleeves as shown.

THE FINISHED DRESS
Just ten steps later, you have this gorgeous dress to enhance your journal page with!

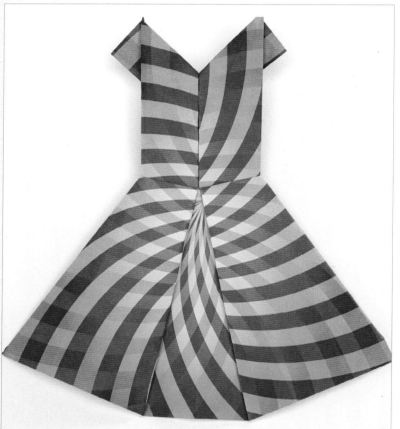

SEE IT IN ACTION!

Go to youtu.be/okCfELW299M to see a video demonstration of how to make an origami dress.

1 LAY DOWN COLOR

Lay down color on the journal page with Tim Holtz Distress Paints. Make dot patterns by "stamping" it, or you can squeeze the tube as you press down for different effects.

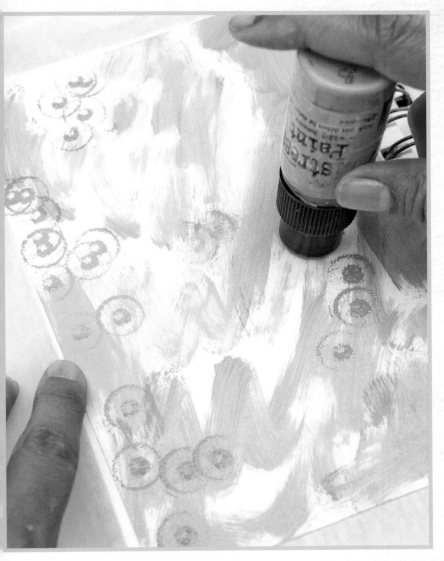

2 ADD COLOR ACCENTS

Use nail polish to add pops of glossy color.

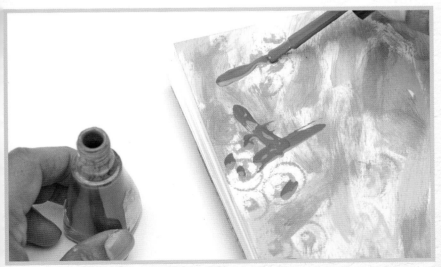

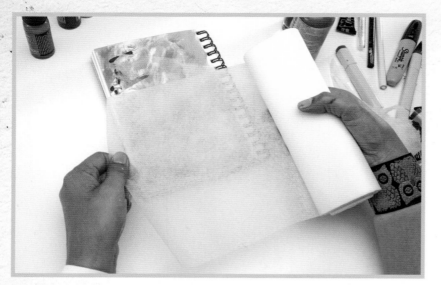

3 · ADD ANOTHER LAYER

For the next layer, tear a piece of rice paper and adhere it to the page with Golden Gel Medium. Use an old credit card to smooth out any bubbles. Do not go all the way to the edge, though—you want those ends to fray up.

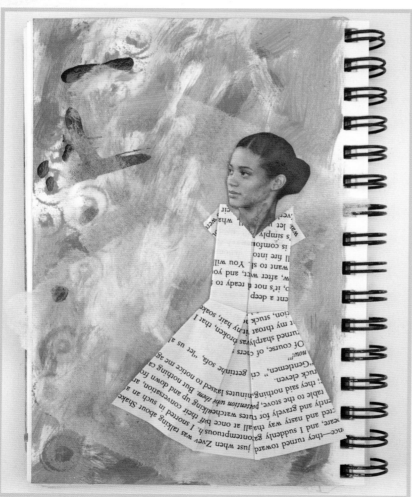

4 · ADD A FACE AND ADHERE IT TO THE PAGE

Cut out an image of a face from a magazine. You could also use a photo of your mom, your sister, a friend or yourself. Glue it onto your fabulous dress and adhere them to your journal page with Golden Gel Medium. (I used an upside-down book page for the dress.)

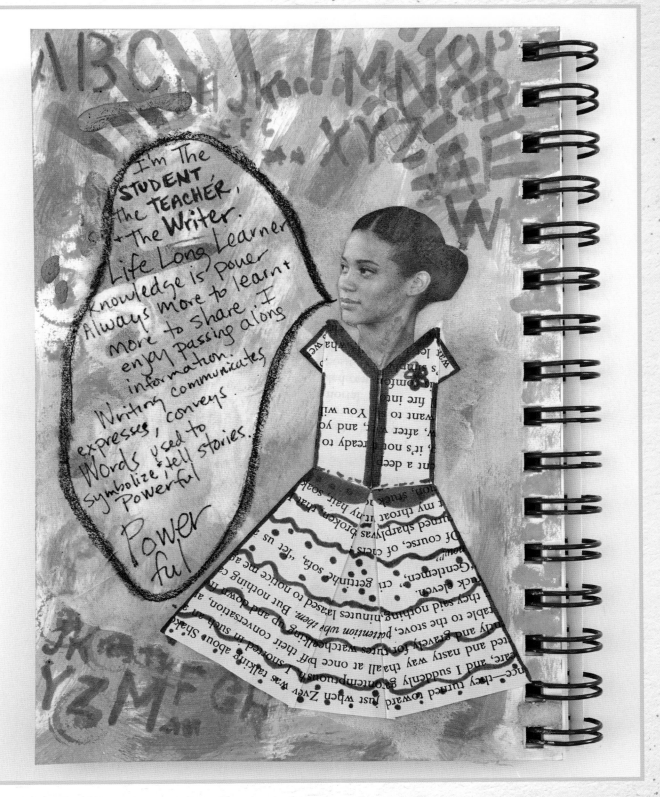

5 ADD FINISHING TOUCHES

Add stencils and decorate the dress. If you like, add a talk bubble to let us know what she's thinking!

THE STUDENT/TEACHER/WRITER
Gabrielle Javier-Cerulli
Mixed-media art journal page with origami.

demonstration

WHIMSICAL GALS

Tamara Laporte creates fantastic people. Often her style is whimsical like this lollipop head. See her page honoring The Mother using this same technique in Chapter 1. I've said it before—drawing people and faces isn't easy for me. But I followed Tamara's step-by-step directions, and I think my gals turned out majestically!

MATERIALS

SURFACE
- art paper or art journal

PAINTS
- craft paint (green or orange)
- high-flow acrylics
- PanPastels
- Tim Holtz Distress Paints (Crushed Olive Green)
- watercolor blocks

PENCILS
- .09 Pentel Graphfear 1000 graphite pencil or a 2B
- watercolor pencils

STENCILS
- Tree of Life by Artistcellar

OTHER
- highlighters
- kneaded eraser
- nail polish

SKETCH FOR QUEEN ART JOURNAL PAGE

1 DRAW THE BASIC SHAPE OF THE HEAD

You can use a good drawing pencil such as a .09 Pentel Graphfear 1000 if you like, but a regular 2B pencil will work just fine for this.

Draw a large circle. To help with facial feature placement, draw a guideline down the center of the face. Then place another guideline across the middle of the face (guideline A). There should now be a + on the face.

Add in two more horizontal guidelines. First add the nose guideline (guideline B). This should be a horizontal line midway between guideline A and her chin. Add the lip (guideline C) by drawing a horizontal line midway between guideline B and her chin.

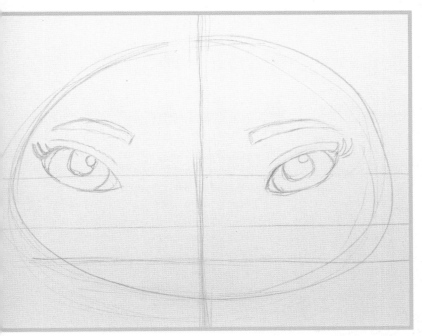

2 DRAW THE EYES

There are lots of ways to draw eyes. (I usually draw eyes on an angle.) For this style of face, you want the space of one and a half eyes in between the eyes. Remember, this is meant to be a whimsical drawing, not realistic.

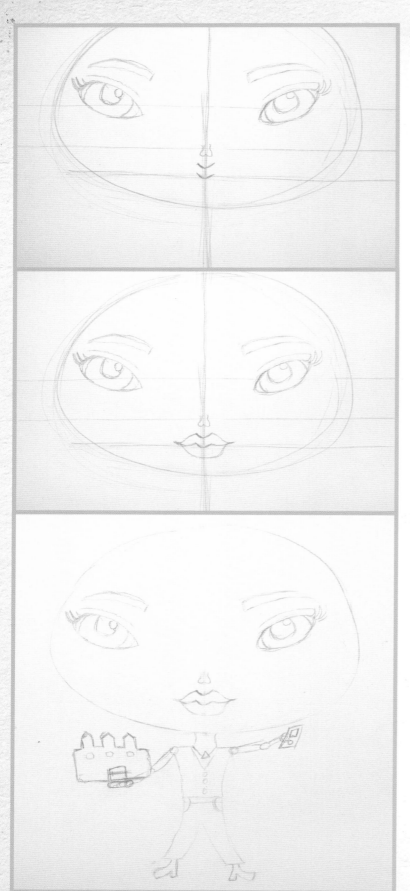

3 DRAW THE NOSE

Draw a hint of a nose at the nose line (guideline B). Adding a philtrum is optional. Draw two Vs under the nose. This will form the base for the lips.

4 DRAW THE LIPS AND ERASE GUIDELINES

Draw the lips. Make the bottom lip more squared up. Erase your guidelines. A kneaded eraser is best for picking up all the lead, and there won't be much residue left behind.

5 DRAW THE BODY

Let's give her a body. This is where you can embellish whatever archetype you're drawing. Whatever details you decide to add here will help showcase the essence of the archetype. (For my Queen, I added a castle, smartphone and high-heeled boots.) When it comes to these whimsical drawings, you can continue with the theme by drawing small bodies. Start with a small neck. Use circles for the joints. You can keep them in or erase them later—it's up to you.

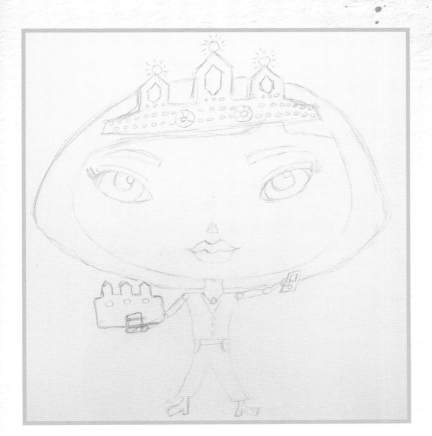

6 **DRAW THE HAIR**

Draw the hair beginning above the skull line. (I usually make a part and bangs.) Erase the skull guidelines. Continue adding her personal details, such as a crown.

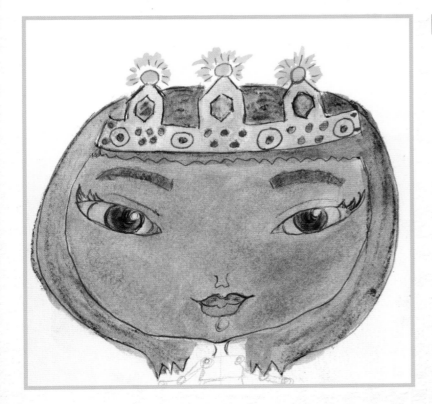

7 **COLOR THE FIGURE**

Color her in with a mix of craft paint, high-flow acrylic paint, watercolor blocks and watercolor pencils. Add white paint or marker pen to the eyes and through the face for light reflection. You will get different effects depending on which medium you choose. If you use watercolor markers, much of your boundaries and lines will disappear, giving your lollipop head a more painterly style. Using alcohol-based markers and pens or acrylic paint will allow any outlines in black pen or Sharpie to remain, creating more of an illustration effect. Use some glimmering nail polish to add shine to the crown.

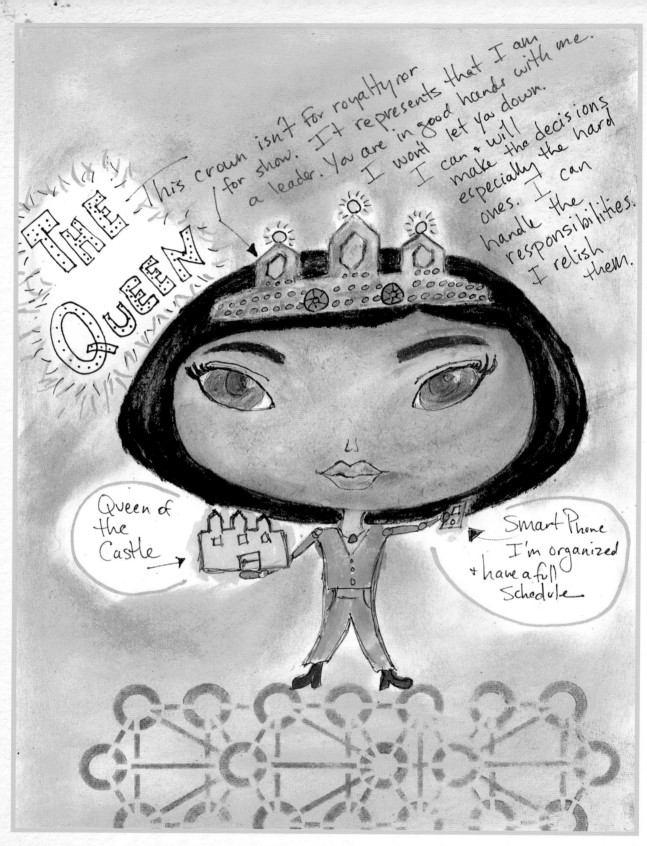

8 **FINISH THE BODY AND PAINT THE BACKGROUND**

Fill in the background with gold and orange craft paint, along with hints of Crushed Olive Green by Tim Holtz Distress Paints. Create a cool base for the Queen to stand on with the Tree of Life stencil by Artistcellar and magenta PanPastels.

THE HEDONIST

She's a foody and loves a trendy cocktail.

THE ATHLETE

She competes, keeps her body toned and needs to be physical.

THE COMEDIAN

She's funny and is always ready with a joke.

CUSTOM ENVELOPES

Envelopes hold information or secrets. But in this tutorial, we'll be emptying an envelope of its words and letters. This technique would be good for The Writer, Scribe, Storyteller and Teacher pages. Or for anyone who is connected to words or fascinated by them.

MATERIALS

PAINTS
- airbrush paints
- high-flow acrylics
- PanPastels
- Tim Holtz Distress Paints

MARKERS
- Copic
- Letraset
- Prismacolor

STENCILS
- Shattered by StencilGirl

OTHER
- 6" x 6" (15cm x 15cm) square origami paper
- alphabet stamps
- glue
- Golden Gel Medium
- ink sprays
- Kreate-a-lope envelope template
- nail polish
- rice paper
- scrapbook paper
- Sofft sponge applicator
- spray bottle or mister
- spray fixative
- wax paper

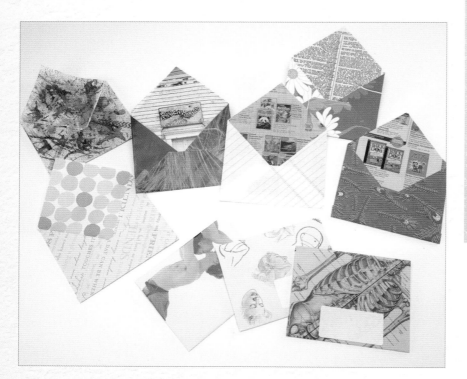

WHY MAKE CUSTOM ENVELOPES?

You can make custom envelopes out of magazines and calendars, scrapbooking paper or Gelli prints. Besides using them in your art journal, you can create envelopes for customized stationery and mail art.

MAKE THE ENVELOPE

There are two parts to the Kreate-a-lope envelope template: the outer piece and the smaller inner rectangular piece.

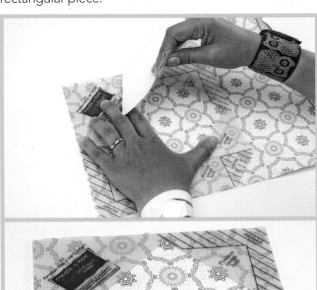

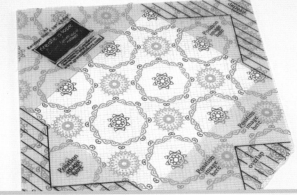

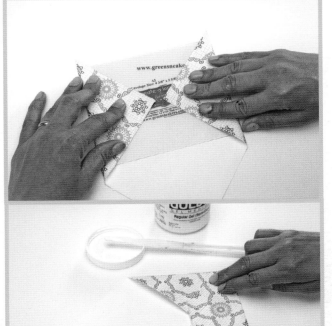

1 PLACE THE TEMPLATE

Lay the larger of the two templates over the front of your scrapbook paper. Whatever appears in the window will be the front of the envelope. Slowly pull the paper all around the edge of the template, including the slanted corner.

2 TEAR THE EXCESS PAPER

Tear off the excess paper. This is what it should look like after you've finished.

3 FOLD THE ENVELOPE

Flip the scrapbook sheet over and line up the template again. Then insert the smaller rectangle template inside the window. Remove the outer template and hold the rectangle in place. Fold the three edges along the template.

4 GLUE THE BOTTOM

Flip the bottom portion up and glue it to the sides.

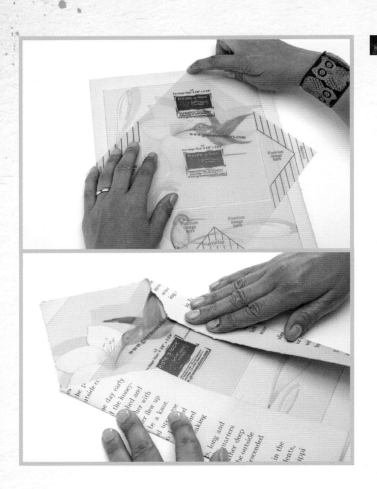

5 **BEGIN THE ENVELOPE LINER (OPTIONAL)**

Make an envelope liner with an interesting/contrasting image or pattern. (This only makes sense if you're going to leave the envelope open, like in the art journal page we'll be going on to make.)

Grab both templates again. Place the large template corner over the image you want and pull away the excess paper. (I used paper with a cute bird image for the liner.) Your sheet will have a point.

Remove the large template, leaving the smaller rectangle. Crease the sides, then cut with scissors along the creases at the bottom. You will have a pentagon shape that looks like a house.

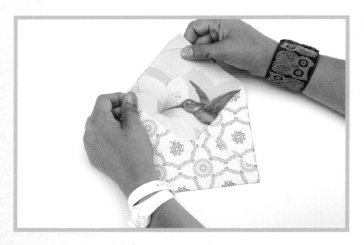

6 **FINISH THE LINER (OPTIONAL)**

Some people will like to keep the envelope as is and some may want to art it up. If you do, first cut out a sheet of wax paper the size of the liner to stick inside the envelope to protect it. Next, go crazy! Stencil, stamp and drip!

SEE IT IN ACTION!

Visit youtu.be/u3SuUtA4ZzU to watch a video demonstration on how to make a custom envelope.

■ DETAIL THE ENVELOPE

1 **CUT AN INSERT**

Cut a mask insert from wax paper. Protect your envelope liner by cutting a mask from wax paper that is the same pentagon-house shape as the liner.

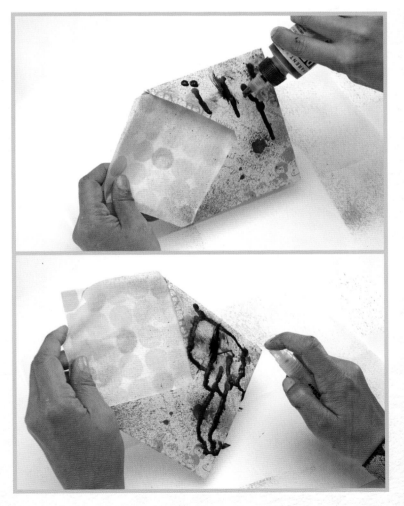

2 **APPLY DRIP EFFECTS**

Use a mister or spray bottle to get a drip effect with ink sprays, high-flow acrylic paint and airbrush paint.

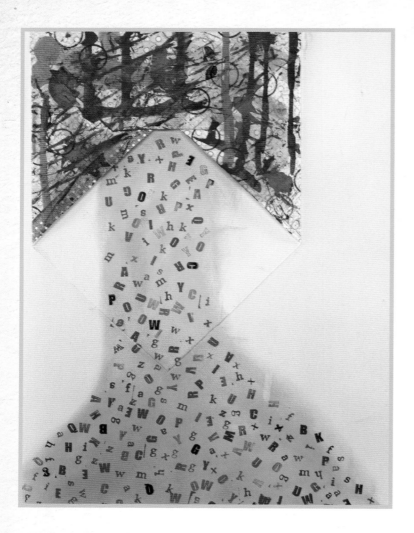

1 **ADHERE THE ENVELOPE**

Adhere a painted envelope to the journal page. Then paint a light color to spill out of the envelope. Next, stamp on letters using two different fonts.

2 **ADD DETAILS**

Using the Shattered stencil, apply PanPastels over the stencil with a Sofft sponge applicator.

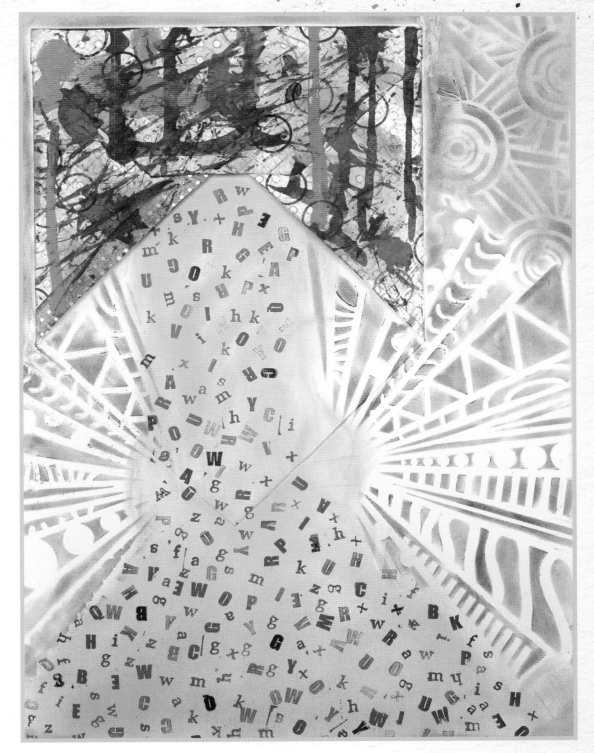

3 **ADD FINISHING TOUCHES**

Re-stamp over some of the letters to make them stand out. Spray fixative on the page because the pastels will smear and eventually flake off.

THE WRITER
Gabrielle Javier-Cerulli
Mixed-media art journal page with Kreate-a-lope custom envelope.

So many words come to them. These words then need to be released and scattered to the world. The Writer cannot keep these words hidden, and once they are released it's a brilliant event.

demonstration
COLLAGE GODDESS

Time for another awesome product shout-out! We played with washi tape in a couple of the previous demonstrations. Now it's time to go the next level with gaffer tape (also known as gaffe tape).

It was love at first sight. I was rehearsing for my TEDx Flour City talk, (I know, I know, I've mentioned it before) and the sound guy was taping down mic wires with this tape that had a soft, lovely texture to it. I had to know what it was! I was off to a sound equipment store the next day. I learned there that gaffer tape comes in other colors than black, like fluorescent orange and pink; and gaffer tape can be easily written on.

Have you used it before? If so, how? Please email me—I'd love to hear your thoughts on alternate uses for this awesome product!

MATERIALS

SURFACE
- art paper or art journal

PAINTS
- Derwent Inktense Blocks
- QoR watercolor tubes

BRUSHES
- medium flat

MARKERS
- Prismacolor
- white Sharpie

STENCILS
- Jane Girls Series—Three-Quarter by Artistcellar

OTHER
- black ink pad
- brayer
- collage materials
- gaffer tape
- glue
- Jessica Sporn Peacock Motif stamp by RubberMoon
- pencil
- wax paper
- white gesso

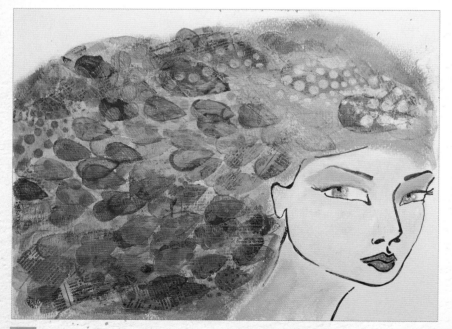

THE GODDESS/WRITER/ARTIST
Gabrielle Javier-Cerulli
Mixed-media art journal page with Jane Girls Series—Three-Quarter stencil by Artistcellar and Rain and Circle Explosion stencils by The Crafter's Workshop.

She is expressive and uses words and color to relate how she feels. Words and torn book pages often make their way into her eye-catching art work that celebrates being a woman. Then she blogs about her finished pieces so others can learn about her process and techniques.

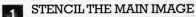

1 STENCIL THE MAIN IMAGE

Use a light tan Prismacolor marker to outline the stencil. Connect the broken dots with a pencil and then go back over the whole outline with marker. Draw a boundary for the hair, then draw in the eyes. When doing the eyes, remember that this pose is from a three-quarter viewpoint, so adjust the direction of the eyes accordingly.

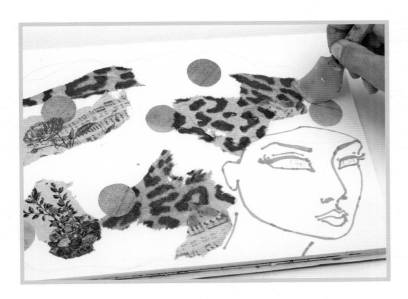

2 LAYER COLLAGE MATERIALS

Glue down collage materials inside the hair. (I glued circles cut from scrapbook paper, ripped patterned tissue papers and a torn cocktail napkin pieces.) Cocktail napkins, also called serviettes, are versatile for mixed-media work. There are usually three layers to a napkin. You want to use the top layer, so peel it off. It will be transparent and gauze-like, which is great for layers.

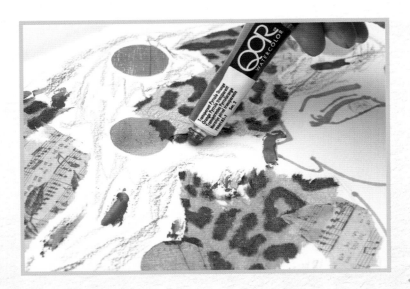

3 ADD WATERCOLOR ACCENTS

Scribble on watercolor crayons like Derwent Inktense blocks and also watercolor straight from the tube. Here I used a tube of QoR. QoR is only a few years old and a product of Golden—yes, the acrylic folks. But they knocked it out of the park with these watercolors. They are vibrant, maintain their consistency and come in gorgeous colors.

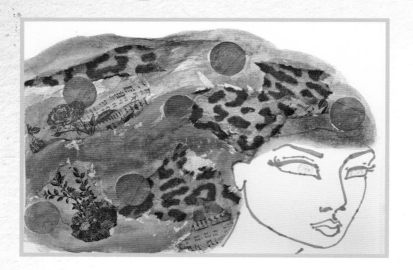

4 **BLEND AND SCRUB**

Blend the watercolor scribbles and paint by wetting a medium flat brush and scrubbing the color and mixing it on the page. Scrub right over the collaged items; you want layers of mixed color.

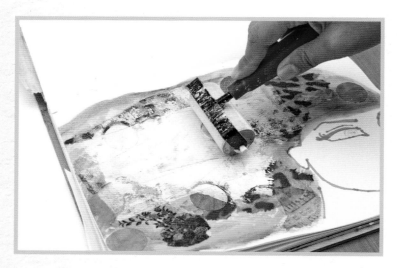

5 **APPLY GESSO**

Apply a thin layer of white gesso using a brayer. This will tone everything down and make it uniform.

6 **STAMP**

Once the gesso has dried, mask off the head part of Jessica Sporn's Peacock Motif stamp by Rubber Moon with wax paper. Stamp with black ink in random places, including over the gesso.

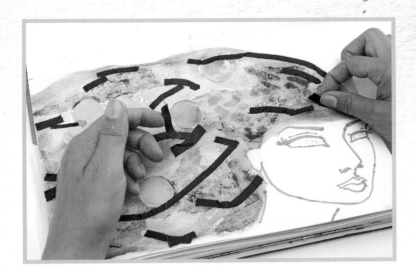

7 ADD GAFFER TAPE

Rip thin pieces of gaffer tape and adhere it randomly throughout the hair by pinching and twisting to make waves that look like ribbons.

After all the tape is down, write on it with a white Sharpie or pen. Write an inspirational quote in her hair, or describe the attribute of the Goddess you just created, or write a reminder to yourself.

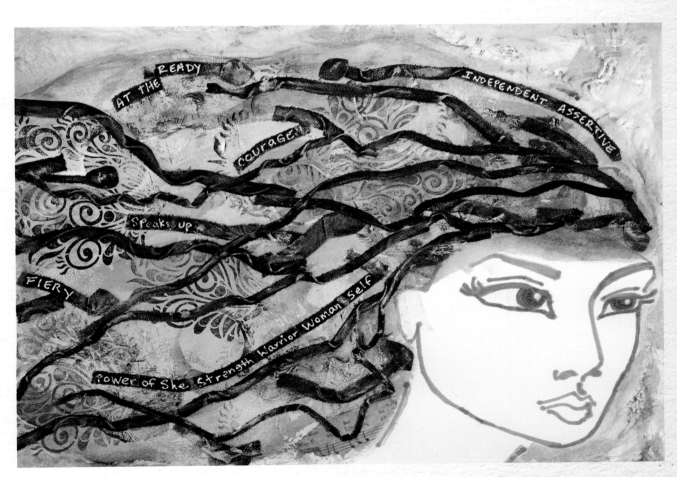

She is beautiful and feminine and also fiery and courageous. She inspires others to be strong independent women with her sure-footedness and assertiveness.

THE WARRIOR GODDESS
Gabrielle Javier-Cerulli
Mixed-media art journal page with stencils, stamps and gaffer tape.

COLLAGE FIGURES

You can create your archetypes by cutting out human forms from magazines or other papers. To make a simple figure, cut out a head, shirt and skirt, then draw in the hair and legs. You can use the faces in magazines but alter them to make them more personal. You can also create animals, imaginary or real, with cut-out pieces. Even if you cut out random pieces with no plan in mind, I bet you can arrange them to create an interesting person, animal, beast or being.

MATERIALS

SURFACE
- art paper or art journal

STENCILS
- Square Rose by Artistcellar

OTHER
- ColorBox stylus
- magazine cutouts
- glue
- pencil
- webbing spray
- white paint

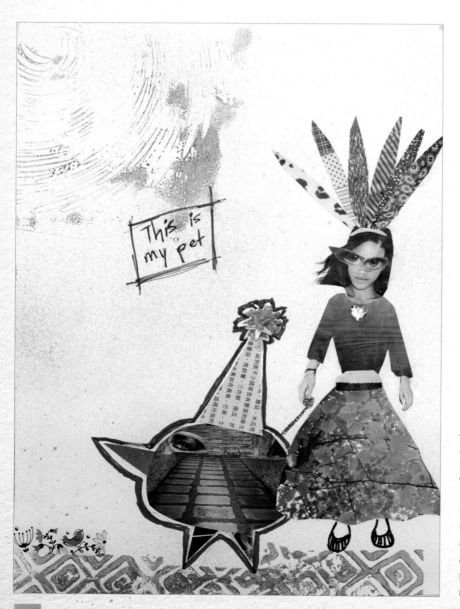

THE REBEL COMEDIAN
Gabrielle Javier-Cerulli
Mixed-media art journal page
with collage.

She lives by her own rules and doesn't keep up with her neighbors. She likes that her pet is totally unique and one-of-a-kind and she likes to dress it up in party hats. She can wear feathers in her hair if she wants; it's a funny fashion statement.

1 SKETCH THE FIGURE

Some people can draw human bodies and faces with such ease. I am not one of those people. I still have to use circle joints to map out the body. (I also have come to like the look of these figures and use them often in my art journal.)

First sketch a side view of your figure. (I sketched a Hermit Nature Gal.) This sketch will help you decide how to cut out the body parts from the magazine pages. You'll have mapped out what angles and shapes to cut the hair, head, legs, arms, etc. (I sketched out a Hermit Nature Gal here.)

2 ADD THE BACKGROUND

Paint a light color on the background. (I did shades of tan.) Then apply silver webbing spray to the page. It's fun stuff! Webbing spray is applied like spray paint, so you'll want to be outside or in a well-ventilated area. Make sure you cover your work surface well because you never know where those little paint particles will fly. Spray webbing comes in black, white, gold and silver. Just imagine what you can do with it during Halloween!

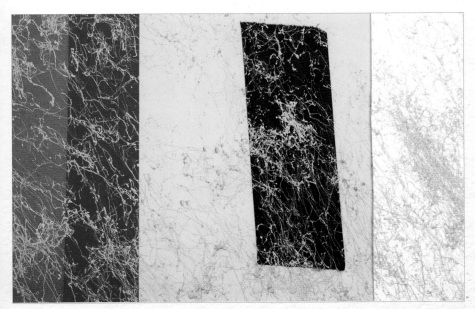

WEBBING SPRAY

Here's an example of silver webbing spray on different colored backgrounds. On lighter backgrounds, it looks more like clouds or mist than webs. On a black background, it looks ethereal.

3 **APPLY STENCILING**

Give it a soft texture by adding flowery images with the Square Rose stencil by Artistcellar. Use white paint and a ColorBox stylus for this..

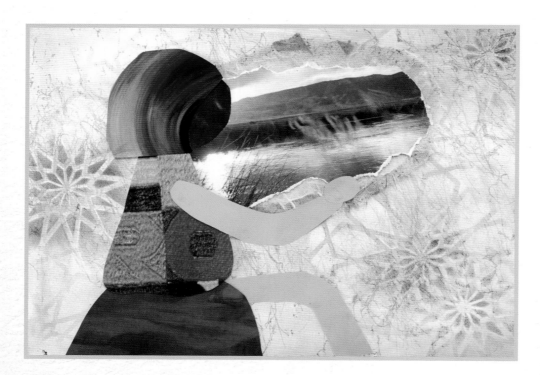

4 **ASSEMBLE THE FIGURE**

Assemble your collage figure and adhere it to the page. I cut out shapes from magazines to create the lady, then tore around the lake image for a deckled effect. Under the lake are two different natural papers.

TAKE TWO

Here's another look at how to plan out a figure's pose. I'm showing this again mainly for those of use who need a little more help with human figures.

1 USE A REFERENCE

For this Hermit Nature Gal journal page, I needed a reference image of a person sitting with their back towards me. Then I sketched out the image to help me understand what body parts needed to be cut and how I was going to cut them.

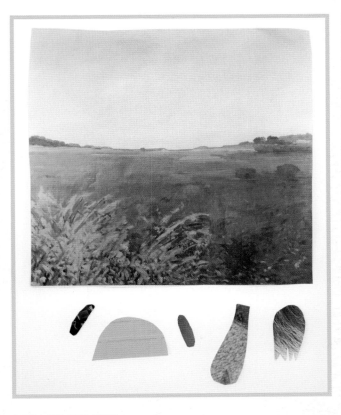

2 CUT PIECES

Cut shapes from magazines. (I have my background image and then on the bottom are the parts for the collage lady.)

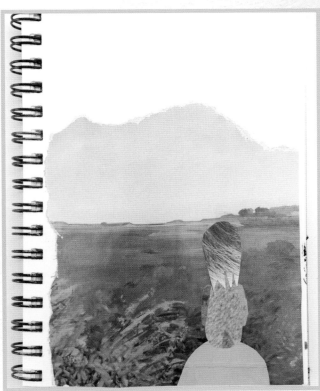

3 ASSEMBLE AND GLUE

Assemble the pieces and glue. This simple page exudes her need for solitude. Her back is to everyone. She only wishes to look forward, by herself, and reflect in the meadow.

MORE COLLAGE FIGURES

These are two more examples of how to use cut-out
magazine shapes and assemble them to create people
and animals.

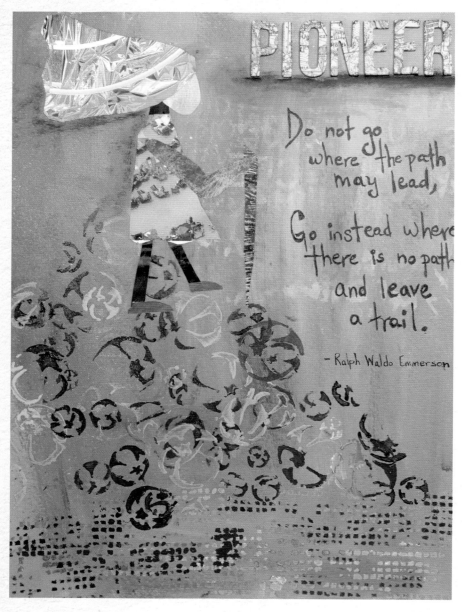

THE PIONEER
Gabrielle Javier-Cerulli
Mixed-media art journal page
with collage.

CREATIVE PROCESS

*I love how this page turned out, though it is often overlooked when folks go through my
stuff. I dig the swing of her hair and the sure-footedness she exudes. I intentionally created a
transparent mountain instead of a thick opaque one. It's to symbolize that many of our mountains
are created in our own minds but in reality they aren't that difficult to climb. We can float on top
of them.*

*The stencils used were Tumbling Pods by Artistcellar for the mountain top and Tile Texture by
The Crafter's Workshop for the ground. Using letter stickers with maps on them creates the word
"pioneer."*

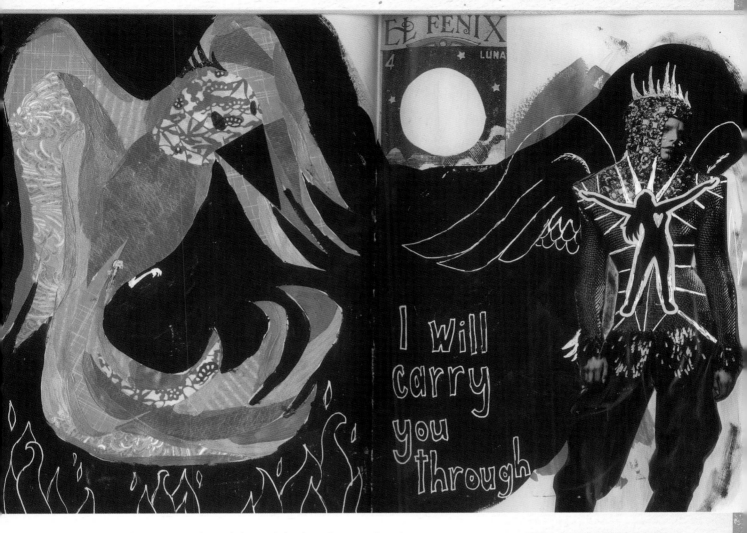

Vanessa Oliver-Lloyd is an art journaler and photographer from Gatineau, Canada.

"The Warrior is a very strong archetype in me. I've always been the defender of the underdog, having been one myself at times. This page was very strongly influenced by my sister. She is younger than me and has been through a lot. I've always had those protective feelings toward her. The Phoenix is a symbol that I associate with her. She has survived many trials and tribulations and has always come out anew. I wanted to show that the power of The Warrior is rooted in this capacity to reinvent one's self and to triumph. The sticker of the silhouette was placed onto the heart of The Warrior, and I added a heart to the woman because I feel that The Warrior's strength always comes from the heart."

I WILL CARRY YOU THROUGH
Vanessa Oliver-Lloyd
Mixed-media art journal page
with collage.

LEARN MORE!

Visit dans-mon-crane.blogspot.com and etsy.com/shop/vanessasfancy to learn more about Vanessa and see other examples of her work.

AIRBRUSH MAGIC

I'd like to introduce you to a new love of mine. It's been around for a few years so you may already be familiar with it. It's the airbrush system that attaches to Copic markers. No need for a massive air compressor or special valves to produce airbrush texture. All you do is stick one of your Copic markers in, attach the barrel to the air can or air compressor and spray away. The result is a cool speckled look.

MATERIALS

- Copic Airbrush System
- Copic markers
- latex gloves
- Schmincke colored masking fluid

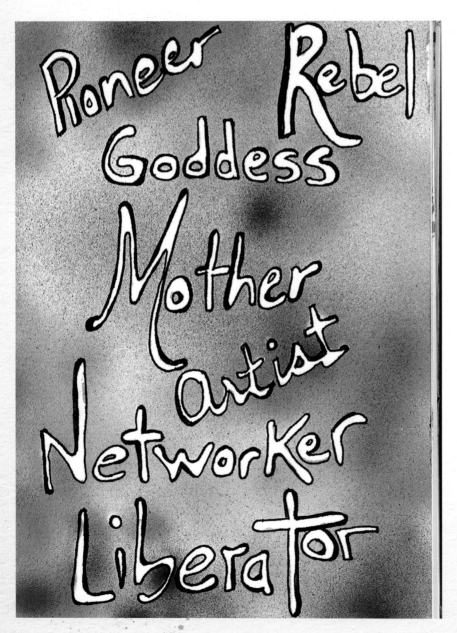

**CORE ARCHETYPES
JOURNAL PAGE**
Gabrielle Javier-Cerulli
Mixed-media art journal page with airbrushing and masking fluid.

1 WRITE YOUR ARCHETYPES IN MASKING FLUID

Use colored masking fluid to write your guiding archetypes out on a journal page.

2 AIRBRUSH

Layer colors by changing the markers in the barrel of the airbrush gun.

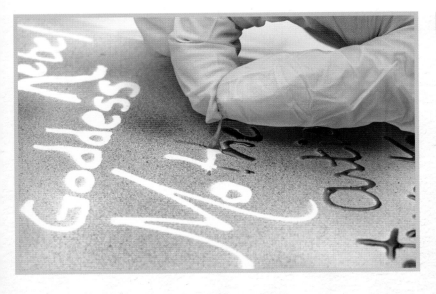

3 PEEL OFF THE MASKING

Peel off the masking fluid.

INDEX

Art Journal Your Archetypes. Copyright © 2016 by Gabrielle Javier-Cerulli. Manufactured in China. All rights reserved. No part of this book may be reproduced in any form or by any electronic or mechanical means including information storage and retrieval systems without permission in writing from the publisher, except by a reviewer who may quote brief passages in a review. Published by North Light Books, an imprint of F+W Media,Inc. 10151 Carver Road, Suite 200, Blue Ash, Ohio, 45242.

a content + ecommerce company

(800) 289-0963. First Edition.

Other fine North Light Books are available from your favorite bookstore, art supply store or online supplier. Visit our website at fwmedia.com.

20 19 18 17 16 5 4 3 2 1

DISTRIBUTED IN CANADA BY FRASER DIRECT
100 Armstrong Avenue
Georgetown, ON, Canada L7G 5S4
Tel: (905) 877-4411

DISTRIBUTED IN THE U.K. AND EUROPE
BY F&W MEDIA INTERNATIONAL LTD
Brunel House, Forde Close, Newton Abbot, TQ12 4PU, UK
Tel: (+44) 1626 323200, Fax: (+44) 1626 323319
Email: enquiries@fwmedia.com

ISBN 13: 978-1-4403-4271-4

Edited by Christina Richards
Designed by Breanna Loebach
Photography by Christine Polomsky
Production coordinated by Jenn Bass

ABOUT THE AUTHOR

Gabrielle Javier-Cerulli is a creative liberator, mixed-media artist and archetype consultant. She is the author of *No Ordinary Woman: Tips for Conscious, Creative and Healthy Living.* Gabrielle has an M.A. in expressive arts therapy and has helped hundreds of people decipher their archetypes to gain clarity and direction in their lives. She also developed her own iPhone app called Archetypes4U.

Gabrielle's honors her **Artist** archetype by fully trusting it and making art a priority in her life. Her visual art fix happens when creating mixed-media artwork, up-cycled pieces, art journal pages, mail art and any kind of abstract art.

She enjoys helping others understand themselves in a deeper way, thus **Liberating** them from being stuck, confused or anxious. This happens when she facilitates archetype sessions, sand tray sessions, art workshops and painting classes.

The **Mother** in her nurtures people and animals (and hopefully a garden one day), and also steers her to be a present parent to her child.

As a **Networker** she brings information and inspiration to those who are seeking it, and connects people to one another. She gets excited about collaborations and seeks them out.

Gabrielle's **Goddess** archetype connects her to the energetic feminine, and she continues to trust her intuition.

Her **Pioneering** spirit ushers her to new adventures (small and large), as she continues to explore and be innovative and independent.

The **Rebel** in her questions the status quo and drives her to make life choices according to her beliefs and not mainstream pressures.

There is an undercurrent of **Love** to everything Gabrielle does, including all of her relationships and artwork. Her heart is open and she consciously tries to give and receive love at all levels.

RESOURCES

STENCILS
- Artistcellar: artistcellar.com
- StencilGirl: stencilgirlproducts.com
- The Crafter's Workshop: thecraftersworkshop.com

ART WORKSHOPS, ONLINE CLASSES AND INSPIRATION
- Seth Apter: sethapter.com
- Orly Avineri: oneartistjournal.com
- Gabrielle Javier-Cerulli: gabriellejaviercerulli.com
- Nathalie Kalbach: nathaliesstudio.com
- Tamara Laporte: willowing.org
- Mary Beth Shaw: mbshaw.com
- Jessica Sporn: jessicasporn.blogspot.com
- Sarah Trumpp: wonderstrange.com

ARCHETYPE CONSULTATIONS
- gabriellejaviercerulli.com/know-your-archtypes
- facebook.com/groups/ArtJournalYourArchetypes

LIFE COACHES
- Tonia Jenny: toniajenny.com
- Dawn Z. Bourand: thewomenofsuccess.com

DEDICATION

To my husband and my son.

I'd also like to dedicate this book to you, my fellow Creatives.

ACKNOWLEDGMENTS

I'd like to thank everyone at North Light Books for giving me this opportunity to help others make more art and understand themselves in a new way. Everyone on staff has a big heart. A special shout out to the soulful sacred art maker Tonia Jenny, who understood and appreciated the vision and potential for this unique book.

To the brave and creative contributing artists who collaborated with me: Seth Apter, Orly Avineri, Lisa Cousineau, Nathalie Kalbach, Tamara Laporte, Catherine Mason, Mary Beth Shaw, Jessica Sporn, Sarah Trumpp, Cybele-Angelique Flematti and Vanessa Oliver Lloyd. I look forward to seeing what comes next for you.

Since the Artist's road is often a solo endeavor, positive feedback and encouragement are always appreciated and needed to keep on keeping on. So thank you, Lisa Rizzo, for your constant cheerleading.

I'd also like to thank my mom, Mary Ann, (big time) for always being there and never, ever trying to clip my wings, and my in-laws Jill and Lou for your constant support and love. A special thank you to my son, Arlo, who brings me so much joy and makes me smile every day. I love love love you!

Lastly, I must thank my husband, Anthony, not only for never trying to clip my wings, but for having wings of his own so we can fly together. Thanks for supporting me through this and many other past and future adventures.

METRIC CONVERSION CHART

TO CONVERT	TO	MULTIPLY BY
Inches	Centimeters	2.54
Centimeters	Inches	0.4
Feet	Centimeters	30.5
Centimeters	Feet	0.03
Yards	Meters	0.9
Meters	Yards	1.1

IDEAS. INSTRUCTION. INSPIRATION.

Find the latest issues of *Cloth, Paper, Scissors* on newsstands, or visit clothpaperscissors.com.

These and other fine North Light products are available at your favorite art & craft retailer, bookstore or online supplier. Visit our websites at artistsnetwork.com and artistsnetwork.tv.

Follow North Light Books for the latest news, free wallpapers, free demos and chances to win FREE BOOKS!

GET YOUR ART IN PRINT

Visit CreateMixedMedia.com for up-to-date information on Incite and other North Light competitions.